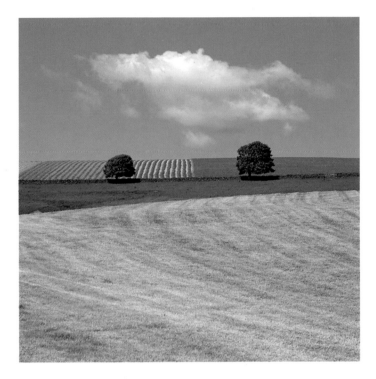

The Making of
Landscape Photographs

Charlie Waite

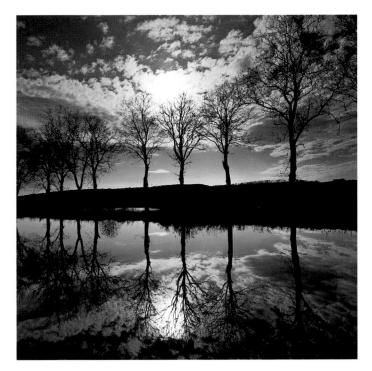

The Making of
Landscape
Photographs

All the photographs in
this book are dedicated
to my dearest friend David.

Acknowledgements
My thanks go to everyone at Toucan, particularly
Robert Sackville West, who first suggested the idea
for this book, John Meek who designed it,
Jane MacAndrew who edited it and,
above all, Adam Nicolson who has been with
me every step of the way.

First published in Great Britain in 1992
by Collins & Brown Limited
Letts of London House
Great Eastern Wharf
Parkgate Road
London SW11 4NQ

British Library Cataloguing-in-Publication Data:
A catalogue record for this book
is available from the British Library.

ISBN 1 85585 069 9 (hardback)
ISBN 1 85585 149 0 (paperback)

5 7 9 8 6 4

Edited and designed by Toucan Books Limited, London

Printed in Italy by New Interlitho SpA, Milan

Contents

Introduction: A Frame of Mind **6**

The Arrangement of Parts **16**
Simplicity **30**
Right Time, Right Place **40**

Lenses **48**
Movement and Exposure **58**
Manipulating the Image **68**

The Play of Light **78**
Colour in its Place **94**

Sky and the Landscape **104**
Water and the Landscape **112**
Buildings and the Landscape **120**

The Big View **130**
The Intimacies of the Landscape **138**

The Final Shape **146**

Glossary **154**
Technical Notes **156**
Index **157**

Introduction:
A Frame of Mind

IT IS NOT always easy to talk or even think about something which you do naturally and instinctively. I have been taking photographs of the landscape almost continuously now for about fifteen years and, rather less often, for ten or more years before that. What I have set out to do in this book is to explore the way some of my favourite photographs were taken – why they work, if they do, how with hindsight I might have improved them, what I learnt to avoid, how I was led many times towards the same certain subjects. Precisely because so much of this was intuitive at the time – the framing of pictures is scarcely a conscious act for me – the writing of the book has been a process of discovery, bringing into consciousness many things which until then had been lurking in the unconscious part of my mind. I only hope that sharing the experience will be of some help to other photographers.

This is not a book about photographic technique. It is, at least to begin with, about an attitude of mind, about seeing what is there in front of you. Later on in the book, there will be chapters about the very specific and detailed ways of handling cameras, lenses, films and filters. But that can wait for a moment. It is important to realise before anything else that all the technology in the world will not matter and all the skill you could possibly muster will not help you move one inch towards a good photograph, if your mind and attitude to the landscape itself is not in the right shape. That is why this Introduction is called *A Frame of Mind*. Your brain and eye are the most important pieces of equipment that you have.

I do not believe that a good photograph can be made without recognising that the landscape will always be more important than either you or the photograph you plan to make of it. Of course it has to be helped and supported by all the techniques of photography, but, when taking a photograph I know to be good, the sensation I always have is a modest one. It is an inner *ah*, the knowledge that something is right. When this understanding is there, something strange happens to me. The heart beat slows down, the whole metabolism seems to come down towards the rate of the landscape itself and the mind, almost as if coated with an emulsion itself, starts to soak up the meaning of the place. There is nothing casual about it. It is not a snatch. Understanding grows as you allow the landscape to come into you. Passivity, not acquisition, is the key to this. A good photograph is a received photograph, an exchange between you and the landscape, in which –

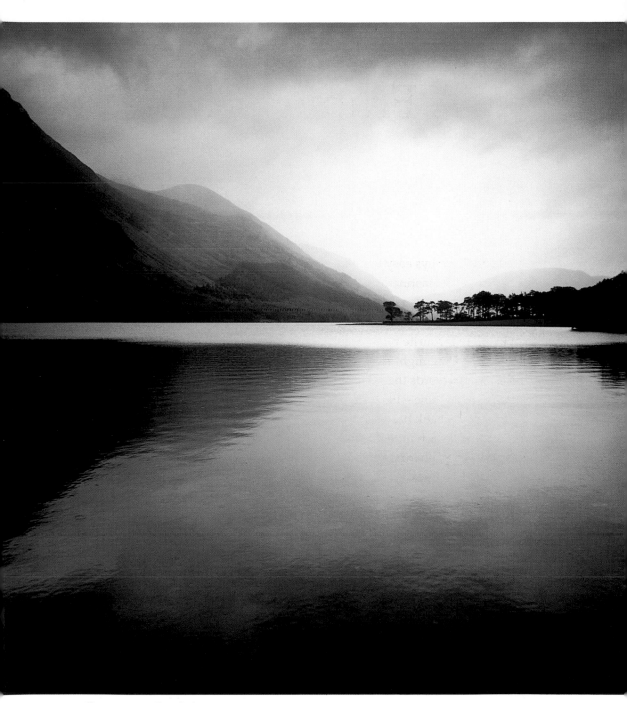

Buttermere, Cumbria

however unlikely this might seem – there is a form of dialogue between the two of you. It is simply courtesy to allow the landscape to speak.

This picture in the English Lake District (above) seems to represent that sort of moment for me. The transmission of the landscape into the photograph is especially pure and uncorrupted. I have not quarried the place, but allowed it to have its say. The picture is not there to make a point. It is simply a recognition, as I see it, of something that is beautiful.

You might ask yourself why anyone should take photographs of the landscape. Perhaps this is too simple a question. The landscape is so obviously a beautiful and alluring thing that even from the earliest days of photography, when it still seemed magical that every detail of a scene could be recorded exactly as it was at a particular moment, people have gone out into the fields and woods to take pictures of them.

But if I had to try to put into words the instinctive feelings I have about landscape, I would say that one of the reasons it draws me – and continues to draw me morning after morning, season after season – is that landscape is something that endures. This is not a temporary thing. I think of those 4,500 million years, the age of the earth. I hold them, as far as one can, in my mind, and the sensation I have is that I am a passenger on the surface of something immeasurably more substantial. And this has a strange effect. I am never particularly worried or disturbed by the presence of a new quarry here or a new road there. In the end, in the sort of time-perspective on which the earth itself works, that will not make the slightest difference. In this reservoir near Pamplona (below) in the north of Spain

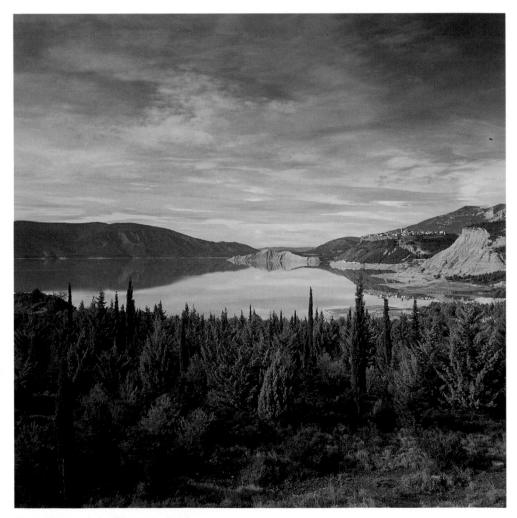

East of Pamplona, Navarra, Spain

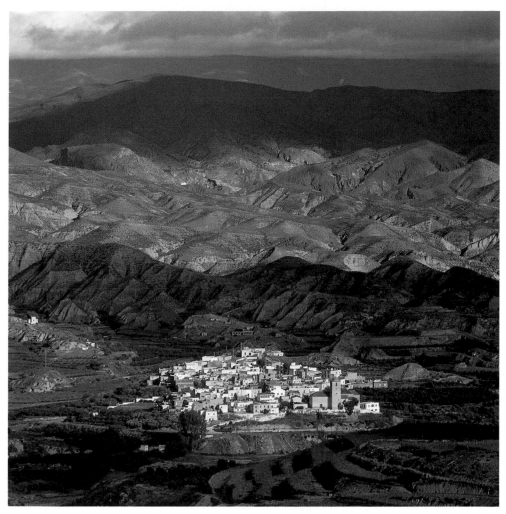

North west of Almería, Sierra Nevada, Spain

or this village in the Sierra Nevada (above) the changes that people have made to the landscape have added to it. And in this way the landscape is a sort of visual memory bank. It is an account of what people and the weather and plants and animals have done there, year after year, layer on layer, slowly accumulating the complex and nuanced patina of meaning which is, I think, what we respond to in the landscape.

The years that I have spent making photographs of the landscape have been a continuous exploration of this extraordinary and resonant surface. Often I have stood for a moment away from the details of camera and tripod and lenses and film, and seen suddenly and again – this is something so important but so easily taken for granted that you need to remind yourself of it as often as you can – that the position we have on earth is, in its way, enormously privileged. The landscape is the thinnest of living veins in marble, squeezed between the giant masses of rock below and sky above. It is where the fluid and mobile element of the atmosphere meets the solidity of earth. That meeting of those opposites is the great drama of the landscape. And of course the catalyst for it all, the one thing that a

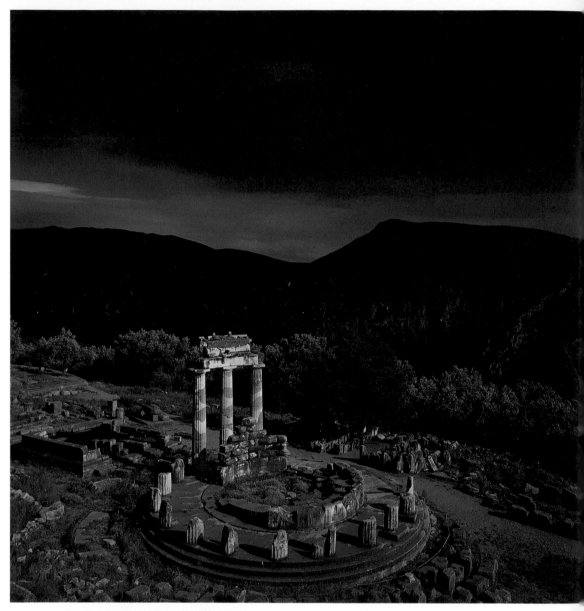

Temple of Athena Pronaia, Delphi, Greece

photographer must know, must learn to understand, must come perhaps, in the end, to love, is light.

Perhaps it is like a love affair. Sometimes the landscape meets you quite willingly, sometimes it is a question of assiduous wooing. There are pleasures in both, but in my experience, the less the image is manipulated, the more perfect the experience for the photographer. Of course there are different grades of manipulation, but if I look at my pictures I will always see them either as pictures which I have had to work for, which are *worked* images in fact, and those which have fallen straight into my lap. I love them both but in a very different way. If it is possible to look at a picture and say 'Yes, I have made that, I have used everything in my power to make something that is pleasing,' then of course there is great satisfaction in that.

The Temple of Athena Pronaia at Delphi (left) is a worked image, one which I can never look at without remembering how I made it. I went back and back to Delphi at different times of day and in different weathers. I felt there was something in this ancient and sacred place which needed to emerge in a photograph of it. And in making the photograph I used all the necessary technical skills – slightly underexposing, darkening the sky with a graduated filter and warming it up with a colour correction filter. I wanted nothing to distract from the form of the temple. I had to wait until there was no light on the hills in the background, I wanted light that was both dramatic and warm – and so on. But I do not here want to go into all the detailed considerations that run through one's mind when faced with something like the temple of Athena Pronaia. The point is this. *The landscape deserved nothing less.* It was right to make it look as it does here, a bright stone laid on a velvet cloth, a thing made holy by the light falling on it and by the shadow enshrining it. It was a question of making an inner and hidden meaning clear.

But there is another sort of picture, one I can look at and see not the picture itself but straight through it to the place I remember. And that experience is one of the sustaining miracles of photography. This picture of a scene in the Alps (below)

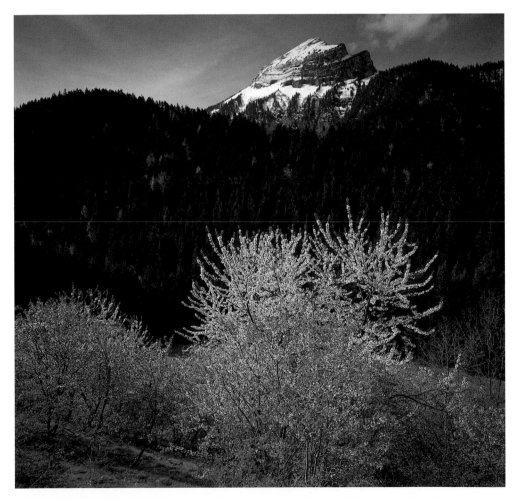

Chamechaude, Isère, France

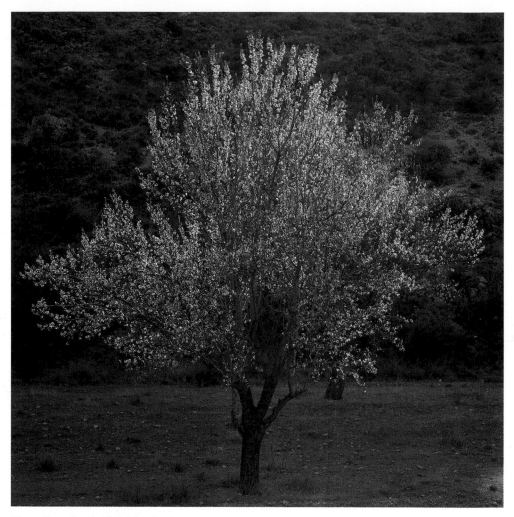

Near Cazorla, Andalucia, Spain

was there as you now see it, perfect and ready. All I had to do was stand in front
of it and drink it in.

But don't make the mistake of thinking that photography will always be a
relaxed process. The photographer who always sees himself as calm and sedate, as
nothing but a slow absorber of the meaning of a place, will more often than not
miss the meaning which the place is trying to offer him. Rush to get it if you have
to, moving as quickly as nature often does. The quick movement, the sudden
noticing of something perfect but passing in its perfection – that too must be part
of the photographer's vocabulary, which goes far beyond the boxes of lenses and
filters. It is a quality of mind. The shutter in the camera will move in tiny fractions
of a second. You must not lag behind.

The difference on the previous page between the photographs at Delphi and in
the Alps – between a made photograph and a photograph which made itself – has
its equivalent in time. The thorn tree lit like a burning bush (above) lasted scarcely
any longer than the second it took to expose the film. Arriving at it in the heart of
Spain, seeing it from the top of the hill as the sun was dropping down, I had to

race to catch the tree before the light had gone. And it is that instantaneous, disappearing nature of the beautiful moment that of course makes it all the more precious. To capture that is something that only photography can do and it is above all – even speaking technically and chemically – a response to what is there in front of you. The light is going, its beauty is there for no more than a few seconds, it is fading before your eyes and you *cannot* ignore it.

But there are other photographs which have to be searched for. You can find yourself in a place where you know there is a photograph, lurking as hidden as a fox in a thicket, which you can sense but not quite see. This glistening rock by a Pyrenean waterfall (below) was something it took most of an hour to find. I clambered around a stretch of hillside where a stream tumbled over a field of wet boulders. Finding a balance between the almost misty water and the great solidity of the stone – I was on the verge of giving up – was a sudden realisation that here was perfection in a looked-for moment, but a moment nonetheless of pure delight.

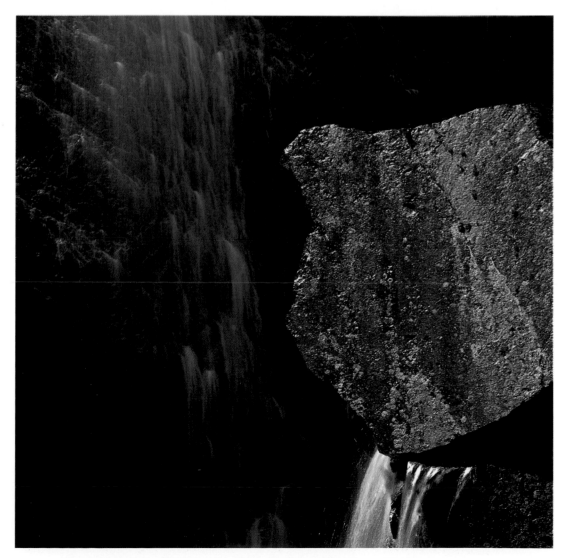

Parc National des Pyrénées-Occident, Pyrénées Atlantiques, France

So be both: both make the moment and take the moment, be acquisitive and absorbent, be patient and be quick.

Sometimes – and it is of course a rarity, something to be treasured and remembered – a landscape becomes in front of your eyes everything you ever hoped a landscape could be. This is difficult to describe as an experience, let alone to attempt to say how one might arrive at it. It is, of course, not something that can be engineered. Partly perhaps it is valuable because it is rare and can only be *given*, not sought or deliberately looked for. It is highly personal. All one can think is 'Yes, for me, what I see in front of me, what I am attempting to record, is what seems to me like a sort of revelation.' That must be the ultimate aim of landscape photography. Its business has to be revelation, in both its senses: a revealing of the

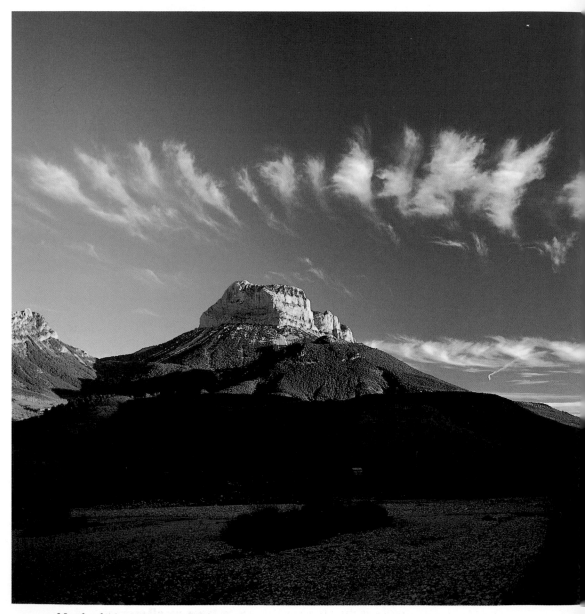

North of Ainsa, Huesca, Spain

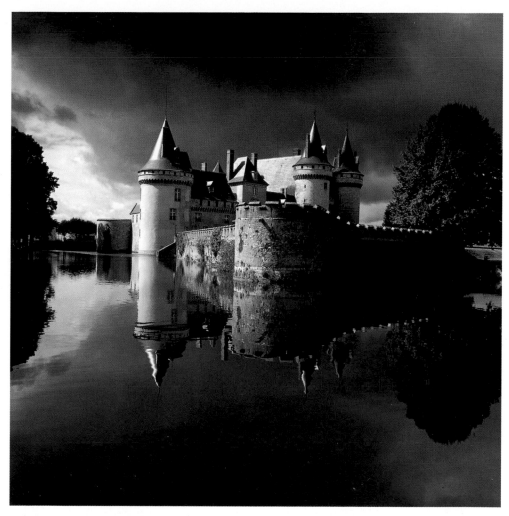

Château Sully, Burgundy, France

material things that go to make up a place; and a channel through and beyond those things into the sort of realities which only revelation in its wider sense can give you access to.

In the body of this book you will find many specific 'Points to Watch' – what and what not to do, an analysis where I can make it of the many elements of the art, what I think I did right and where I went wrong. But it is important to remember that these things, the machinery of photography, are no more than a means to an end. It is easy enough – and a blind alley – to mistake those means for the end itself. That is the route of the man who knows so much about the woofers and tweeters on his hi-fi that he cannot listen to music. Perhaps I should say 'Beware the Points to Watch. They are not what it is about in the end.' But what, you might say, is it about? One is left with something alarmingly difficult to define – the sudden recognition of the beautiful. This either is or is not there. And when it is, the memory of it – and the photograph is nothing but a marvellously concrete form of memory, a denial of time which people before the last 150-odd years could only have dreamt of – is the priceless thing which we are all seeking.

The Arrangement of Parts

Organising the elements of a landscape is often the key to taking a good photograph. The themes in this chapter highlight the importance of making the most of what is there, knowing what to conceal or reveal, arranging the parts to create the best visual image and allowing the character of the landscape to speak for itself.

I WAS IN YORKSHIRE, in the Pennines. I stopped the car and felt the compulsion to go up to the brow of a little hill and look over. This is what I met on the far side: faultlessness staring me in the face. This impeccably maintained piece of landscape has the air of designed wholeness, a set-piece tableau in which every part might have been put there not with efficient farming in mind but the creation of a beautiful cloth, a perfect suit in which to clothe the earth. Everything works: the river provides a good thick generous stripe along the bottom of the picture; the liquid curve of the track that sweeps up from the bridge is fitted sweetly into the shapes of the hill (sweetly in the sense that a ball will sing effortlessly and cleanly away from

the sweet spot on a bat). The walls step back into the distance with a regularity and sharpness that is as satisfying as the precise interlocking noises made by the shutter as it opens and closes. The barns punctuate the picture, pinning it down, giving it an exact sense of scale.

It is a marvellous order. There is no uncertainty here. Everything is congruent with everything else. It is a picture of complete but relaxed control, as pleasing as a mown lawn scattered with the sort of eyecatchers with which an eighteenth-century grandee would have decorated his park.

This photograph is simply a recognition of what is there. The farmers and builders of Swaledale have done all the work.

16

UPPER SWALEDALE, WEST YORKSHIRE

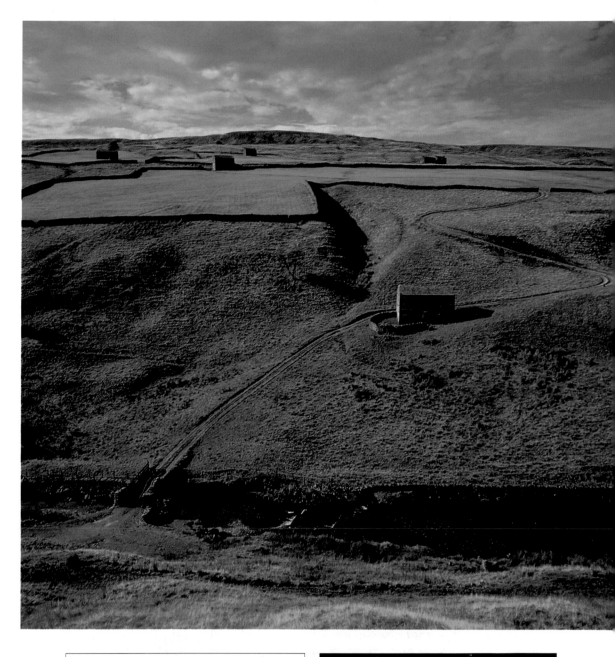

Film: Ektachrome 64 ASA
Camera: 6 x 6 centimetres
Lens: Short telephoto
Exposure: 1/2 second at f.32
Filter: Polarising

POINT TO WATCH

● *In a big landscape such as this, watch out for the direction of the light. Here it is from the side, lighting the end walls of the little barns and throwing their faces into shadow. This is important because it makes the buildings substantial and three-dimensional. Sun coming from behind the camera would light the front walls and throw the side walls into shadow. They might then have looked simply like stage flats and the reality of this amazing scene would have been reduced.*

The Graphic Image

SOUTH OF SIENA, TUSCANY

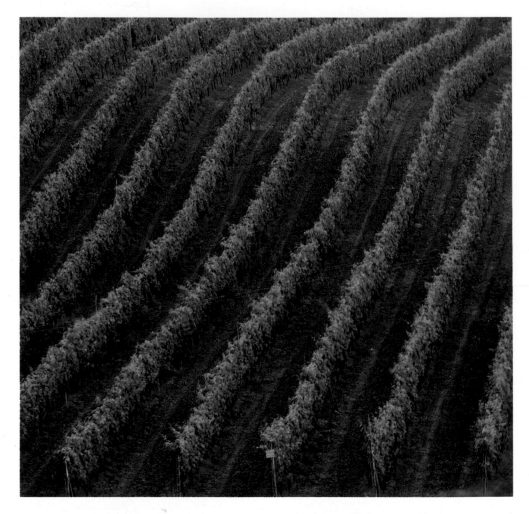

Perhaps the landscape is at its simplest and most shapely, when the elements within it are almost graphic. If the landscape seems to be drawn, then you can be sure that it has the makings of a photograph.

Of all forms of agriculture, the vine is perhaps the most tightly controlled. To respond to that, the photograph must join in with the spirit of its subject. The elements must repeat as they do here. Anything – such as the sky – that distracts from the purity of the graphic image must be excluded. Even the posts at the bottom are a distraction. Put your hand over them to cut them out and see how it improves the picture.

Once the picture has established this simplicity, there is a great deal to be said for returning it to some of the idiosyncrasies of the real world. That is why the ripple in the vines at the back give a visual twist to the picture, a flip of reality, without which it might have dried up into a diagram.

Film: Fujichrome 50 ASA
Camera: 6 x 6 centimetres
Lens: Telephoto
Exposure: 1/2 second at f.45
Filter: Polarising

POINTS TO WATCH

● *Use a long lens to compress everything, flattening a landscape into a graphic pattern.*
● *Simplicity of pattern needs to be matched by simplicity – and strong contrast – in colour. Here the presence of only two colours strengthens the photograph.*

The key to this picture is the placing of the trees in a line along the foot of the frame. This breaks all the conventional rules of composition, which insist that the main focus of interest in a picture should come a third or two-thirds of the way into it. But to put them here was obvious to me from the start. There was a large expanse of green field at the bottom of the picture and to have included that within the frame would have distracted all one's attention away from the string of little globes that line the boundary between the grass and the dark of the hillside in the background.

I have tried to make the pattern clear by allowing the little pom-poms to dominate. They can only do so if they are allowed to be the most vibrant moment in the frame.

Film: Fujichrome 50 ASA
Camera: 6 x 6 centimetres
Lens: Telephoto
Exposure: 1 second at f.45
Filter: Polarising

POINTS TO WATCH

● *A weak sky might have been removed from the top of the photograph. It distracts attention from the pom-poms of the trees.*

● *The light coming into the trees from the back casts big clean pools of shadow in front of them. Crisp cast shadows like this always add three-dimensionality to photographs and help 'point out' the line of trees.*

● *If I could have arranged it, I would have preferred greater separation between the trees, especially at the edges of the frame, where individual trees should not be cut in two.*

NORTH OF VALENCE, VERCOURS

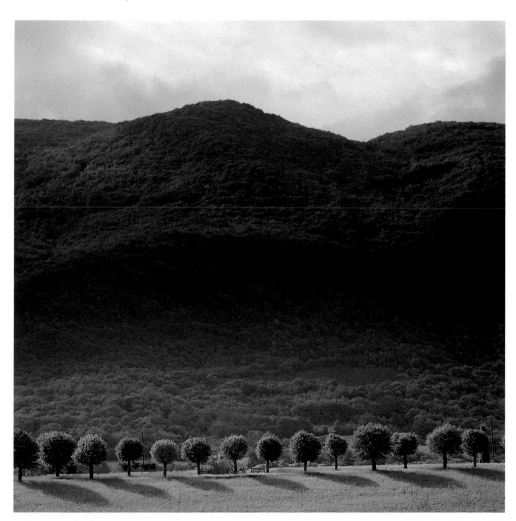

Perfect Balance

NEAR MARTEL, LOT

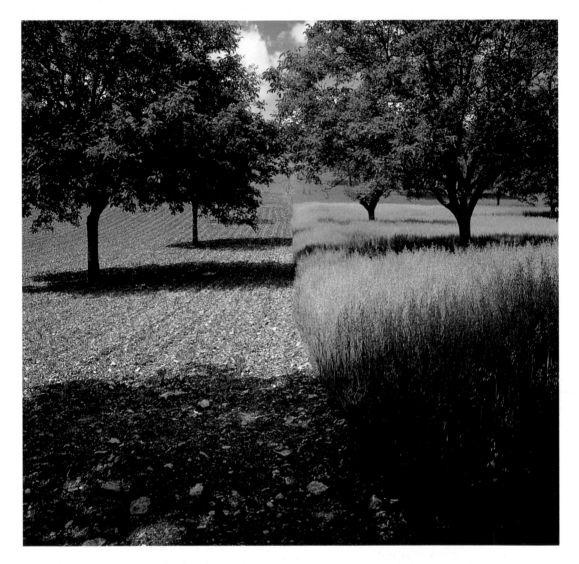

This picture always confuses people. The first reaction is always 'You've stuck two pictures together.' But I haven't. This is how it was. It always pleases me when I look at it that the division down the middle follows right through to the back of the scene, picked up by the fence in the distance. The sense of balance – or perhaps one should see it as complete imbalance – has a time element in it too. This has all the appearance of a before-and-after picture, although it was captured in a single moment. A friend once said to me that it has 'the appealing strangeness of a real scene.' I like to think of it as the landscape playing games.

Film: Ektachrome 64 ASA
Camera: 6 x 6 centimetres
Lens: Wide-angle
Exposure: 1/2 second at f.22
Filter: Polarising

POINTS TO WATCH

● *Ideally the sky should be bland. The blue is intrusive and so are the clouds. The perfectionist would have returned another day. But if the sky had been bland, there would have been no shadows and the picture would have suffered.*

● *The polarising filter has been used to deepen the green of the oats. The pay-off for that is no light in the shadows.*

THE COVE, AVEBURY, WILTSHIRE

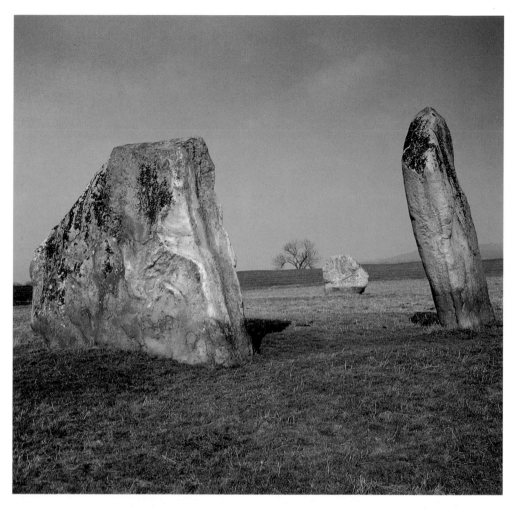

Of course the landscape rarely provides you with as clear-cut a symmetry as the field in Martel (opposite). Usually the balancing of the elements within a picture is subtler, takes longer and involves a series of intuitive judgements.

These Neolithic standing stones at Avebury in Wiltshire are a case in point. What works here is the bringing of two very different things into a satisfactory relationship with each other. The large wide stone seen edge on and the plate of rock on the left are visually as different as Morecambe and Wise, but they complement each other: a balance not of equivalents but of opposites.

The tree in the background delineates the horizon and fills the gap between the stones. The effect – and this is something you have to feel your way towards – is of objects arranged with care and attention.

Film: Ektachrome 64 ASA
Camera: 6 x 6 centimetres
Lens: Wide-angle
Exposure: 1/4 second at f.22
Filter: None

POINTS TO WATCH

● *The very soft lighting, almost without shadow, reveals the texture of the stones. Something much more harshly lit would have thrown the photograph out of kilter. Remember that highlights and shadows will always play the role of additional objects in the landscape. An arrangement of parts made in one set of lighting conditions is unlikely to work in another.*

● *This is a classic instance of not snatching at a view. The role of the background tree is crucial here, but it took a while to realise that. Never forget the details. On them the balance will tip.*

The Lighter Touch

LAC D'IRATI, PYRENEES-ATLANTIQUES

The arrangement of parts discussed so far in this section has been a question of rather strict formality. But the principles at work in those strictly arranged photographs are still relevant even when the landscape presents a looser and baggier face.

This lake is high in the French Pyrenees, where the luxuriant beech wood is one of the marvels of Europe, dripping with early-morning dew like a freshly washed salad.

Formality has been allowed to relax here, but you can still feel the structure of the place. This is helped by the most simple of structural elements – the reflection of the arc in the waters of the lake. You might think that, with all that is going on at the right-hand side, it would become unbalanced, but the reflection compensates for this.

Cut that out with your hand and you will see how the whole picture slumps to the left. There is no need for complete symmetry.

Film: Ektachrome 64 ASA
Camera: 6 x 6 centimetres
Lens: Wide-angle
Exposure: 1/8 second at f.16/f.22
Filter: Polarising, half-polarised

POINT TO WATCH

● *The image of the sky reflected in the water is more interesting than the sky itself, because less light is reflected off the water and the exposure can pick up the variations of light and shade. A grey graduated filter over the sky would have reduced the brightness to that of the reflected image and improved the picture.*

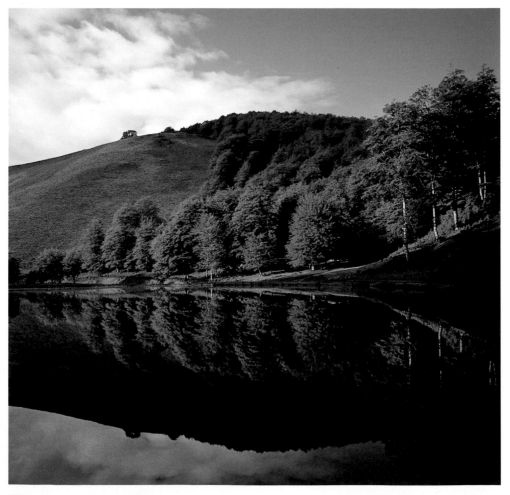

PIC D'IRATI, PYRENEES-ATLANTIQUES

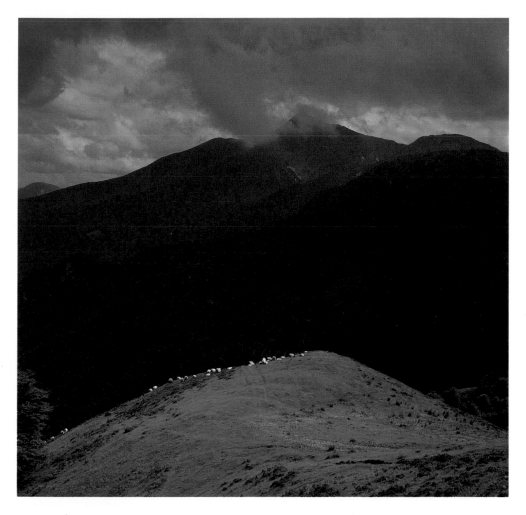

This photograph was taken the following day. There was hardly any sun, only the odd flash of light creeping through the clouds. The picture would not have worked unless the sheep had been there, marking the edge of the hill. They give life to the whole scene. The mountain background, which is dark and inanimate, is brought right up against the lit and living rim of the hill. The flock is crucial to the picture because it delineates the elements within it. This is a dramatisation of the elements in the landscape, perhaps in the same way as the photograph on page 11, where the white blossom and the white snow bridges the distances that separate parts of the mountain world. But again, the control is not rigid here. The flock is no more than a light flick with the point of the brush, something slight in a landscape of great size and visual violence. This is not a photograph cramped by strict graphical control. (Consider how far it is from the vines on page 18.) But perhaps this slightness of control in a picture is, in the end, more satisfying.

Film: Ektachrome 64 ASA
Camera: 6 x 6 centimetres
Lens: Short telephoto
Exposure: 1/4 second at f.32
Filter: None

POINT TO WATCH

● *I would have preferred the sheep at the very bottom left of the frame not to be there . They muddle the clarity of the picture's idea. But photography is certainly one of the arts of the possible and stage direction of sheep is not – yet – one of my skills.*

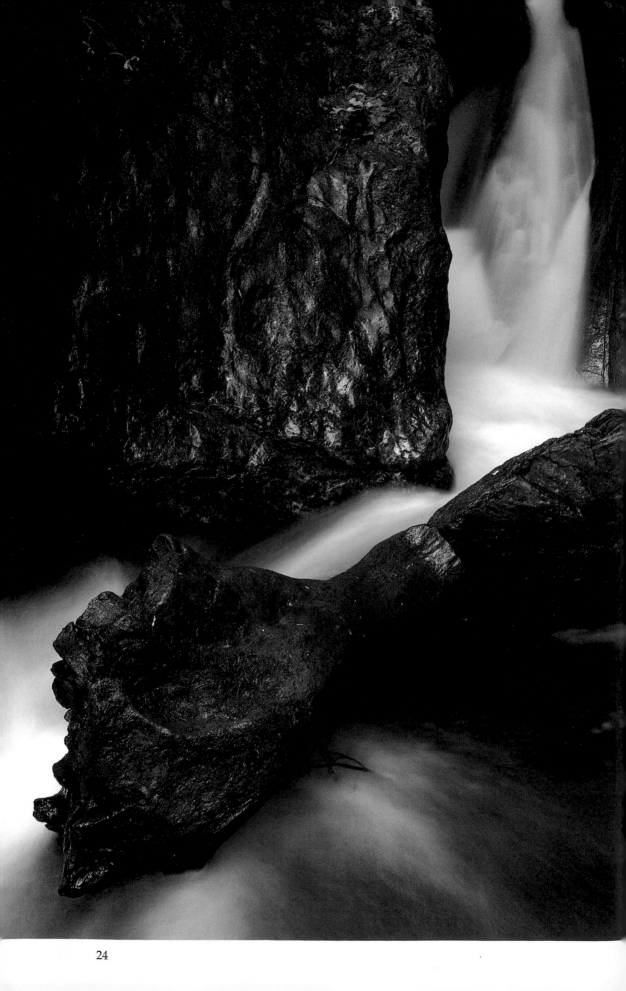

Making the Picture Right

WATERFALL AT LAC D'AUBERT, PYRENEES

I want to describe the stages by which this picture was taken. I was driving along the shore of a lake. The road crossed a bridge over a mountain stream and I stopped. The end of a waterfall, where it meets a lake or the sea, is usually the least interesting part. But there is always a point where the water falls vertically down the rock and I walked upstream looking for it. You need to have a picture in mind, but you must also be open to the landscape and alert to its opportunities.

Once I had found the place came the long process of selection to make the picture right. This picture is close up to its subject. If I had moved further out, it would have included the untidy woodland to left and right; in fact, I am not entirely happy with the bits of green on the right. I wish that there were only two colours in the picture – those of the rock and the water. But to have gone in any closer, removing the green, would have lost the gush of water on the left. Block that side out with your hand and you will see how the picture is diminished.

There was equally little choice about the upper and lower limits. The lowest point of the log-like rock needs to be there, as does the point where the stream emerges at the top. Hold your hand across either of those two, and the point of the picture is lost.

Film: Fujichrome 50 ASA
Camera: 6 x 6 centimetres
Lens: Wide-angle
Exposure: 2 seconds at f.22
Filter: 81b warm-up

POINTS TO WATCH

● *The rock face to the right of the fall in the background was already glistening with spray. But the large face to the left was dry and unreflective. So I splashed it with water from the stream to make it shine. Never hesitate to make temporary changes to the scene in front of you.*
● *I used a long exposure to soften the water and make it silky. This also revealed the structure of the water's movement down the fall.*

The Chosen Space

RIVER DOVEY, POWYS

I was faced with a choice here, the sort of choice on which the whole art of photography hinges. These two photographs were taken one after another, with no horizontal movement of the camera. One is simply lifted higher than the other. There is no doubt in my mind which one works best; it is the picture above covering acres of sky. It may be because there is a technical pleasure in it. You can hardly ever

Film: Ektachrome 64 ASA
Camera: 6 x 6 centimetres
Lens: Short telephoto
Exposure: 1/4 second at f.32
Filters: High-density grey graduated; 81b warm-up

photograph sun except at the very end of the day. Here, because of the particular half-transparent clouds, I could get a picture of it high in the sky, its tiny disk no bigger than

26

RIVER DOVEY, POWYS

a fingernail. You can see why in Ancient Athens when scientists calculated that the sun was slightly bigger than the Peloponnese, they were generally thought to be mad.

That is the sort of satisfaction that comes not from a photograph but from the actual process of photographing it. It should not in the end govern one's ideas about a picture.

But the reasons for my preferring the 'sky' picture to the river picture are quite straightforward: the sky is so much more interesting to look at. The dazzle of the reflected sunlight is more dramatic than the flatter light of the picture above, and the patterns of light and dark far more dynamic. It is the difference between an ordinary somewhere and a place you might travel miles to visit – a difference made by tilting the camera five or ten degrees.

Film: Ektachrome 64 ASA
Camera: 6 x 6 centimetres
Lens: Short telephoto
Exposure: 1/4 second at f.32
Filters: High-density grey graduated; 81b warm-up

POINTS TO WATCH

● *Tilt the camera by as little as five or ten degrees to achieve a completely different picture.*
● *A massive grey graduated filter was necessary to 'bring in' the sky. Without it the sky would have been enormously overexposed. The way to judge the strength of graduation that is needed is to look at the sky with your eyes half shut. If you can only do so with your eyes virtually closed then you need a heavy one. If you can look more wide-eyed at the sky, then a lighter filter will be all right. This gets easier with experience.*

A Place in its Place

BARMOUTH, GWYNEDD

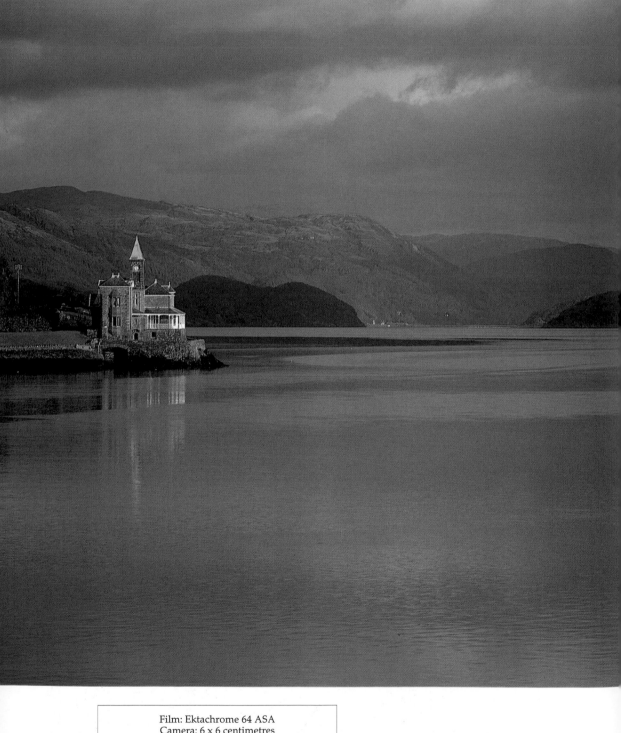

Film: Ektachrome 64 ASA
Camera: 6 x 6 centimetres
Lens: Short telephoto
Exposure: 1/2 second at f.32
Filter: Low-density grey graduated

Again, a single place provides its choices. I far prefer the picture on the opposite page to the one below. The mass of mountain in the background is so much greater and makes the Victorian building look, as it surely was intended to, much more vulnerable than it does below.

I thought at first that a notched and craggy outline to the hills behind would make more of an impact, imposing the mountain presence more forcibly on everything below it than a flat horizon could do.

But then I moved to the position from which the picture opposite was taken. Look first at the differences in the water of the estuary. It is both more patterned and somehow more serene than in the earlier picture. The black utterly unlit hump of land in the distance and the way the water stretches continuously towards it give one a greater sense of distance and dimension. It is a grander picture, the grandeur surrounding the sweetness of a Victorian house squeezed between the mountains and the sea.

POINTS TO WATCH

● *The lower light in the picture on page 28 means that the exposure is a little darker.*
● *Consider carefully what it is that you need from a photograph and then go out to find it. You can actively seek it.*

Film: Ektachrome 64 ASA
Camera: 6 x 6 centimetres
Lens: Short telephoto
Exposure: 1/2 second at f.32
Filter: Low-density grey graduated

BARMOUTH, GWYNEDD

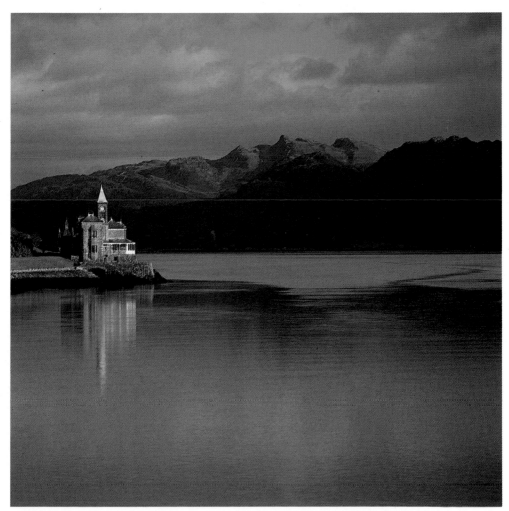

Simplicity

The simplest photographs are often the most successful.
This chapter shows how, by seeking simplicity in the
landscape – either by isolating a single object or by reducing
a natural scene to a few interlocking elements – a pattern
emerges, and a strong visual effect can be achieved.

I AM WALKING along the salt-marsh lawn on the edge of a river estuary in Normandy. The river is a plane of glass. The morning is cold but brightly lit, a perfect clarity in the air. Then this, a fishing boat hauled out on to the bank, its shape, colour and setting all perfect. The picture made itself.
I changed only one element in the scene, letting the chain, which had been curled up inside the boat, hang down towards the mud. Why did I do that? I'm not sure. It quite simply seemed better that way, visually attching the prow of the boat to the ground on which it rested.

But that chain is symptomatic of something that is critical in a photograph like this, where the main outlines of the picture are quite straightforward. And that is the all-

important role played by what seem to be comparatively unimportant elements.There are several here without which the picture would fall apart. Hold your thumb over the brightly lit patch of mud left of the boat; and then over the bright transom on the right. As you do so, you see meaning and coherence drop away. Even stranger is the part played by the rather shapeless clouds at the top. Block them out with your hand and the picture becomes unbalanced, full of too much grass. To make it work again you have to cut away most of that grass in the foreground, but then the image becomes pinched and the boat is not given its place in the landscape.

It is one of those photographs from which nothing can happily be removed.

THE ESTUARY OF THE SEE, AVRANCHES, MANCHE

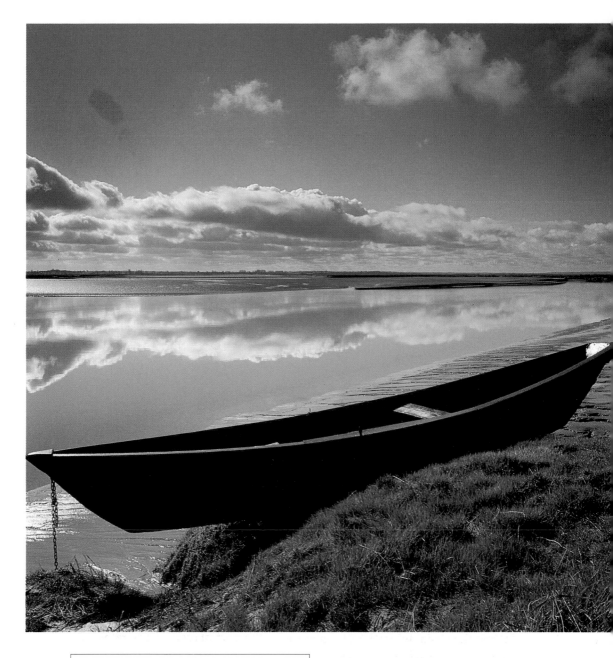

Film: Ektachrome 64 ASA
Camera: 6 x 6 centimetres
Lens: Standard
Exposure: 1 second at f. 22
Filter: Polarising, fully polarised

POINTS TO WATCH

● *In a backlit picture, look out for direct light falling onto the lens, which causes flare. To prevent this, shade the lens with your hand or a lens-hood.*

● *Harsh sunlight leads to loss of detail in the shadows, but if the composition is strong, don't worry. High contrast, in fact, improves the image, pushing it towards an abstract.*
● *With close-ups, be careful about the foreground. The picture could have been improved if I had taken a little more care by cleaning away the dead grasses and scattering loose grass on the patch of white clay on the left. This would have both clarified and balanced the photograph.*

A Single Remark

EAST OF CORDOBA, ANDALUCIA

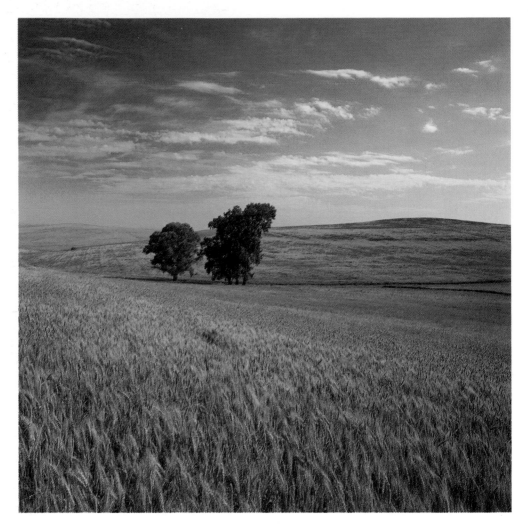

Put your thumb over the trees in the picture above and what do you get? An advertisement for the Ukraine in the Soviet Agricultural Weekly. Of course the barley is beautiful, in that perfect midway stage between green and gold, a month or so before it is ripe and harvested. But without the trees the picture degenerates into a bore.

There is no great mystery to this: isolate anything and that very isolation will make it more important.

This may be an easy thing to do but it is not to be despised. It allows one to see something plainly, to hear a single note and to remove distraction. And what in the end can be the point of landscape photography but to see something properly and for itself?

Film: Fujichrome 50 ASA
Camera: 6 x 6 centimetres
Lens: Wide-angle
Exposure: 1/4 second at f.22
Filters: Polarising, fully polarised; 81c warm-up; low-density grey graduated

POINTS TO WATCH

● *There was no wind when I took this picture. This was absolutely necessary to get the definition in the ears of the barley, as a relatively long exposure was needed for the depth of field.*
● *A deep dark sky would have been wrong. This is a breezy light picture and all the colours needed to conform to that.*
● *A mild warm-up filter was used to emphasise the yellow latent in the barley.*

EAST OF SINALUNGA, TUSCANY

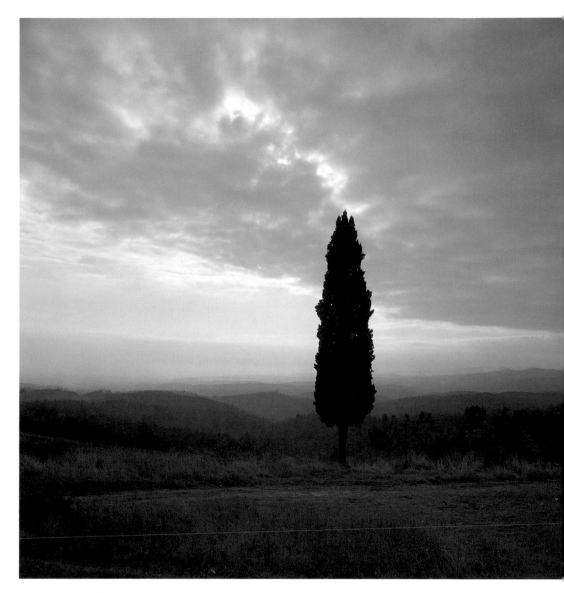

I love this picture of the single tree. It is an image of utter solitude against a grey bank of cloud, a single remark dropped into a virtual silence.

Perhaps it is more what surrounds the tree than the tree itself that makes this photograph – the beautiful opening sky after rain, and beneath it the softened colours of the evening landscape, each colour folding into the next. It is, for me, like one of those moments of which only great music is capable, when the mood subtly alters from violence to a new and washed calm. The solid presence of the tree is needed to fix that moment.

Film: Fujichrome 50 ASA
Camera: 6 x 6 centimetres
Lens: Wide-angle
Exposure: 1 second at f.22
Filter: 81b warm-up

POINTS TO WATCH

● *Always watch out for litter. You cannot tidy it out of the picture later. I should have tidied up the foreground here more than I did.*
● *It would have been absolutely wrong to put the tree in the middle. It needs to be, even if almost unnoticeably, a little off to one side. I am not sure why, but I often offset a main subject slightly to the right.*

The Complete Picture

I ALWAYS TRY to recreate in a photograph the feeling you get when you suddenly see or hear something beautiful for the first time. It's the sensation of 'That's it! There is something perfect', the feeling that raises the hairs on the back of the neck. I don't know what it is that produces this sensation, but one part of it is certainly the impression of completeness, that something has been caught whole and nothing is left unexplained.

NEAR S. GIMIGNANO, TUSCANY

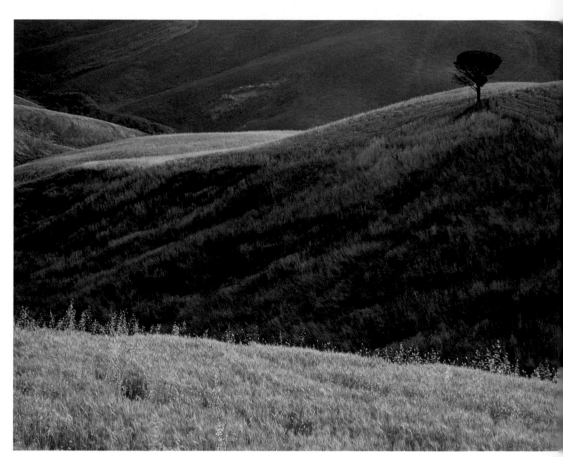

Here, the evening light with its long shadows and almost sculptural separation of foreground from background creates a rich textured shape which the flatter light of midday would not have achieved. As it is, the light reveals the place. The single tree is a necessary accent. (Cover it with a finger to understand its importance). But one extra element makes the picture complete; the wind on the valley side in the middle distance has ruffled the grasses, softening them as though the valley is coated in the fur of a cat. There is unexpectedness in that, introducing a subtle air of movement.

Film: Fujichrome 50 ASA
Camera: 6 x 6 centimetres
Lens: Standard
Exposure: 1/2 second at f.22
Filter: 81b warm-up

POINTS TO WATCH

● *Use amber warm-up filters to emphasise the golden light of evening.*
● *Remove the sky from a photograph to maintain overall control of the colour range.*
● *The little patch of green on the left of the frame is to my mind a fault in the photograph. It could not be avoided; immediately to the right was a large field of bright green wheat.*

NEAR RONDA, ANDALUCIA

CAMARGUE

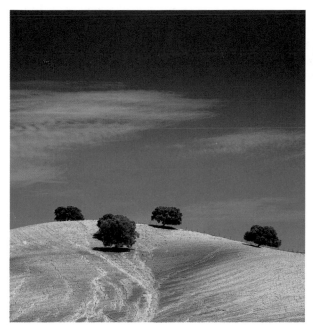

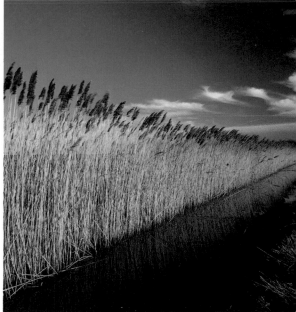

The air of completeness in this picture is achieved by almost exactly the opposite means of the previous one. Here every element stands out in complete distinction from the rest: each of the four colours is almost undilutedly itself; the hill, trees and sky are pure blocks of colour. In the Tuscan photograph every element complements and enhances the others; here the whole is made by the bringing of sharp opposites together. The Tuscan photograph *suggests* completeness, this one demonstrates the clarity of trees on a white hill under a blue sky.

A third way of achieving this air of completion is this; the single receding structure. There is nothing complicated about the picture. Blue and yellow are at opposite ends of the spectrum and to bring them so closely together enhances both colours. The polarising filter deepens all colours, particularly the blue of the sky, but that adds little to what is there anyway. I love this picture, partly because it is so simple. When something is as perfectly complete in itself as this, then the photographer can, or should, have little to add.

Film: Fujichrome 50 ASA
Camera: 6 x 6 centimetres
Lens: Short telephoto
Exposure: 1/30 second at f.11
Filter: Polarising, half-polarised

Film: Fujichrome 50 ASA
Camera: 6 x 6 centimetres
Lens: Wide-angle
Exposure: 1/2 second at f.22
Filter: Polarising, fully polarised

POINTS TO WATCH

● *The photograph would not work without the cloud, which in some ways mirrors the texture of the field. Always wait for the sky to come right.*
● *The midday light creates only very black shadows under the trees. In these conditions look for 'false shadows', as from the colours in the earth of the field, to give shape to the landscape.*
● *Avoid the mistake I made here with the tree on left, which emerges from the hill without its trunk.*

POINTS TO WATCH

● *The polariser, to darken the sky, eliminates much of the reflection of the reeds in the foreground. This is simply a choice one has to make; I felt more was gained this way than lost.*
● *The great depth of field necessary to bring the whole line of reeds into focus made a long exposure necessary and a couple of reeds are blurred in the wind. Ideally, I should have waited even longer for complete stillness.*

Reducing a Picture to Match its Subject

ISLAY, INNER HEBRIDES

A single object – a boat, a swan, a tree – always works in a photograph, no matter where it is. It is both an image of romantic isolation and a picture of simplicity. And that itself is a pleasure to look at, reducing what you see to a single meaning, shutting out extraneous things because they have no business being there, a vision of something pure and simple when usually what you get in your view of the world is a buzz of disorganised information, the everyday restlessness of things. The single object in a wide expanse is the embodiment of calm.

But there is a danger. The lonely object may be too lonely. It may actually disappear into the picture it is attempting to control. I think that might be a problem with the uncropped frame here. But there are also other things at work, all of which need sorting out. First, to have the horizon coming halfway up the picture is a mistake because dividing the picture-space precisely in two is a formula for imbalance – the two halves struggle too equally with each other. I could have pointed the camera higher into the sky, but higher up, on this evening, the sky was losing its beautiful mottling. Even in the upper reaches of the photograph as I took it the clouds have started to get too light and lose their texture. But there is a solution to these difficulties. In fact, this is an occasion where the true meaning of the photograph is revealed only by cropping it quite radically, reducing the landscape to the simple and evocative width of a panorama. The boat, simply by occupying a larger proportion of the picture space, has taken control of it. The beautiful and very slight ripples in the lit water on the left-hand side become visible for the first time.

Film: Fujichrome 50 ASA
Camera: 6 x 6 centimetres
Lens: Ultra wide-angle
Exposure: 2 seconds at f.22
Filter: Polarising

POINT TO WATCH

● *Control of the horizon is quite obviously completely critical here. Check it with a spirit level after every exposure.*

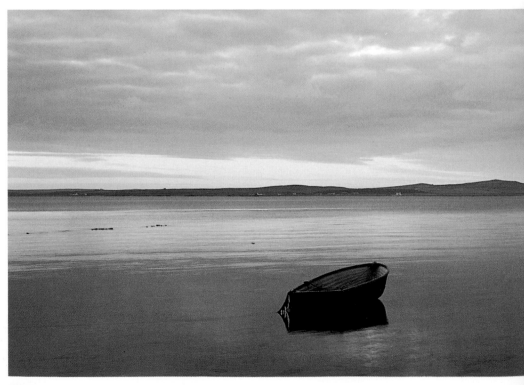

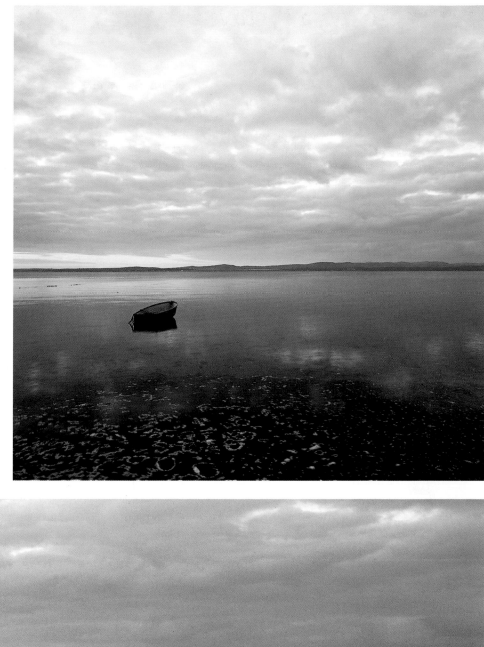

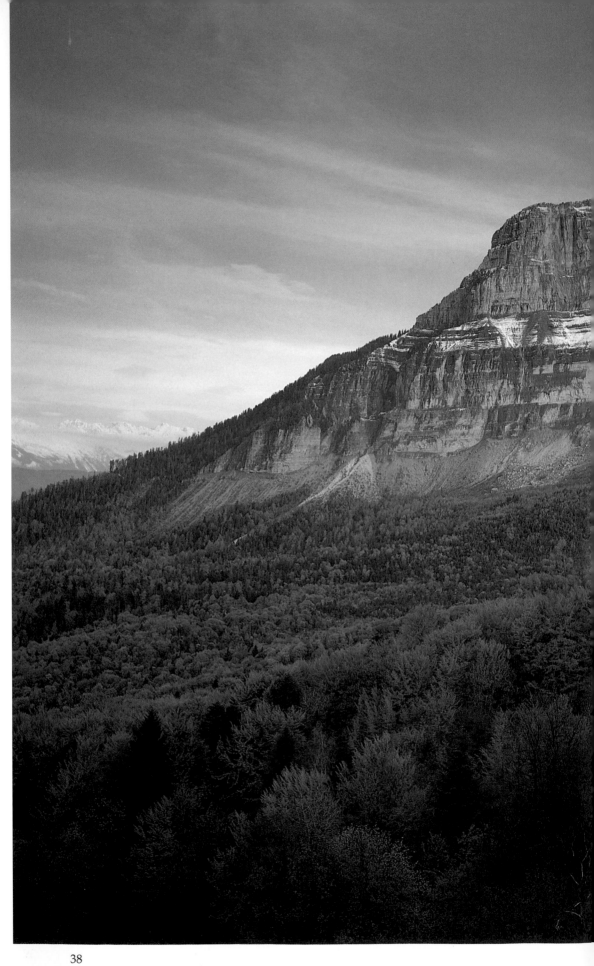

The Monumental Object

MONT GRANIER, SAVOIE

Here, quite simply, the whole landscape has become a single object, so that the mountain stands like a sculpture on a plinth. The limestone massif dominates the place and the job of excluding distractions is already done magnificently, monumentally, for you.

Various other elements are highly important to the success of the picture. It would not have been enough to point a camera at a big lump of rock and hope for this atmosphere of massive dominance.

The lighting conditions happened to be perfect, slowly changing in the finest gradations from the deep shadow at the bottom right to the climax of the lightest part of the stone face. The fine scatter of snow over the high rock works as a sort of artificial highlight.

This is a subtle effect, the tones working with the geometry of the picture, but it is important. The light establishes, probably subliminally, the huge emergence of the mountain above the valley. Without it there would have been far less *intelligibility* in the landscape, little to lead you from foreground to background. The mountain, at least in these terms, would have been inaccessible.

All this is helped by the simplicity of the light. It is almost shadowless, very late in the evening and the photograph is taken with a long exposure. That too adds to the air of monumental calm.

Film:Fujichrome 50 ASA
Camera: 6 x 6 centimetres
Lens: Standard
Exposure: 1/2 second at f.22
Filters: None

POINTS TO WATCH

● *Lit snow remains white. If any of the snow had been sunk in shadow it would have gone blue and would have needed an 81-series warm-up filter to correct the colour.*
● *The mountain is pushed slightly to the right of centre. To have had it in the very middle would have destabilised the picture.*

Right Time, Right Place

Chance favours the prepared mind and both planning and luck play their part in creating a good photograph. Think ahead, prepare for the weather conditions you might expect and remember, for example, that big views are almost always better in the morning and evening. But also take advantage of the unexpected and be prepared to experiment.

WHEN I ARRIVED in this field it was winter, perhaps late autumn. It was 6.30 in the morning and the field was empty. I was taken not with any particular element in the landscape in front of me but with the way that everything here fitted with everything else: the softening early-morning light, the mist coming off the grass, the way in which colour was drained out of everything. The cows wandered in from somewhere off left.

As I think one can see in the photograph, if you look at it carefully, analytically and ungenerously, the actual elements in the picture are not that attractive. The houses are dull and the church too stern. At another time of day I would not have bothered with the place at all. But here, with a light mist

that takes out the colour but allows detail to remain in both the buildings and the sky, it was a picture worth getting up for.

And that is a phrase of which, if you pursue photography with any seriousness, you will continue to remind yourself. The light of mid-morning, noon and afternoon is rarely the light that will reveal the nature of a place. Low light, whether at evening or early morning, will always find its way into the corners and create the sculptural shadows that a photograph needs.

But it is not simply revelation that you are after here. Concealment, the suggestiveness of low light, the simplicity of the light before dawn, perfect in its grey shadowlessness: these are the circumstances in which good pictures will happen.

STROSSWIHR, NEAR MUNSTER, VOSGES

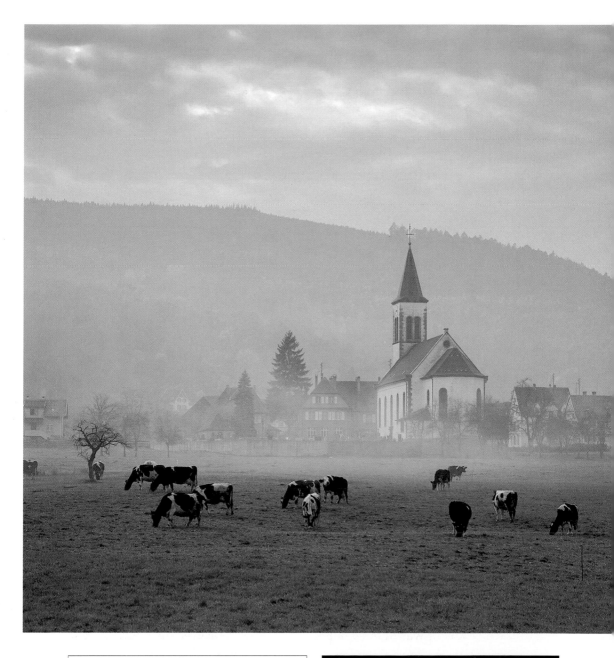

Film: Fujichrome 50 ASA
Camera: 6 x 6 centimetres
Lens: Wide-angle
Exposure: 1 second at f.22
Filters: 81b warm-up

POINTS TO WATCH

● *Don't ever allow the point of a steeple to interrupt a skyline. Use a ladder to keep the tip of the steeple within the hill in the background.*
● *With a flock or herd of animals try not to have them masking one another, but distinct as they are here. A full, patterned spread will always look best.*
● *The house and the animal's bottom at the far left should be cut out. Always go for clarity; make the meaning clear.*

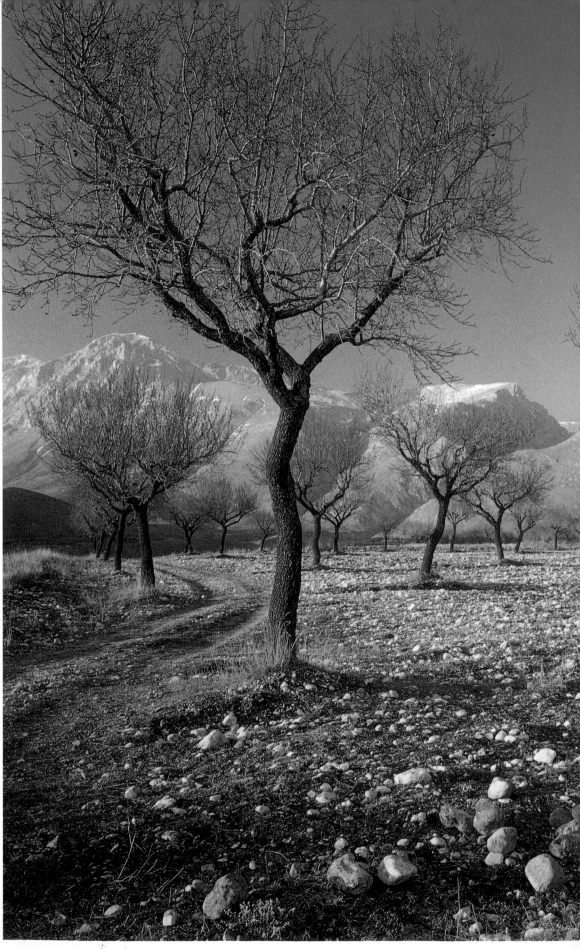

The Revealing Winter

WEST OF CELANO, ABRUZZI

In the very middle of the winter at the end of the afternoon, I can feel myself still being invited into this picture. It makes you want to walk into it, doesn't it? I would like to tell you, as I know it looks, that this upland valley, high in the Apennines, was rigid with frost at the time. It wasn't; I was rather hot, in shirtsleeves.

But everything about it speaks the Mediterranean winter. It is sharp at every point. Nothing is muffled or clothed. Trees, soil and mountain are all naked. At any other time of year the trees would have concealed each other and the distant mountains – that all-important baseline against which the things near at hand need to be set – would have been invisible. This is the revealing winter in which the low light and long shadows reveal the texture and nature of the rocky soil as if the nap on a cloth has been raised. Landscape photography is not only for the summer. In some ways it comes into its own when looking at the bare bones of winter.

Film: Fujichrome 50 ASA
Camera: 6 x 6 centimetres
Lens: Ultra wide-angle
Exposure: 1/8 second at f.22
Filter: 81c warm-up

POINTS TO WATCH

● *I should really have stepped back a few yards to try to encompass the trees in the foreground, not to clip them at the edges. In a photograph where the whole point is clarity and revelation, try to ensure that shapes remain whole.*
● *I have wondered if the use of the 81c warm-up filter is too much here. It is necessary to take the blue out of the shadows on the snow but is the effect now too yellow?*
● *Try to achieve a formal balance between the foreground and background which is satisfying. Here I feel the relative weights of tree and mountain are about right.*

The Investigating Light of Evening

NEAR MELROSE, BORDERS

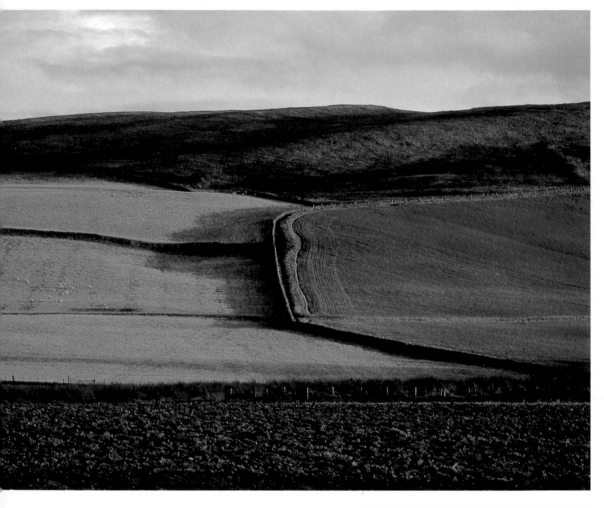

What is this picture about? It is of course the meeting of two fields and two colours, separated by a single low wall. It is a simple pattern, a classic instance in fact of a landscape becoming attractive through the reduction of information. But this photograph would not have been half what it is here if it had been taken in the more vertical and whiter light of the middle of the day. Here the low, raking light of evening makes – through the large shadow – the substance of the wall much more real. The low light is the only set of conditions in which the full potential of the place could be completely realised. The long lens, as always, has led to a loss of definition, but in a picture of such warmth and larger blocky effects, this is not important.

Film: Ektachrome 64 ASA
Camera: 6 x 6 centimetres
Lens: Telephoto
Exposure: 1 second at f.22
Filters: None

POINTS TO WATCH

● *This is a cropped photograph. A great deal of the foreground which would have distracted from the main point of the picture has been eliminated.*
● *Block out the sky with your hand to show how the yellow becomes the most important patch in the photograph, tightening the picture up. Would cropping the sky out improve it?*
● *The colours in the evening are much richer than in the middle of the day. The depth of green is almost too much. Perhaps a little earlier in the evening would have suited the place more.*

44

SOUTH OF SIENA, TUSCANY

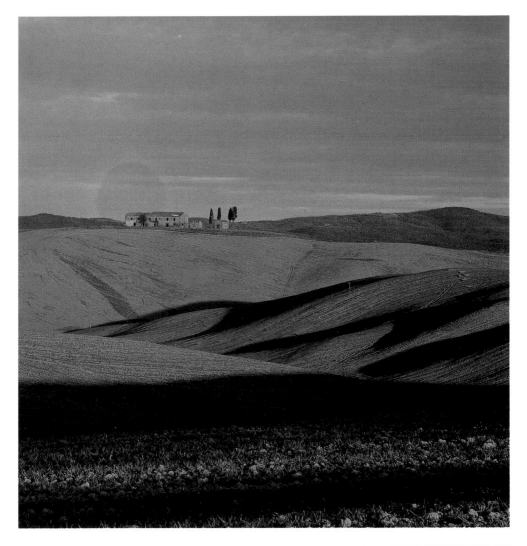

The subtler the shapes of a particular piece of country the more investigative the light needs to be. The fine modulations of a gently billowing field only emerge in light that glances off the rounded ridges and throws the troughs between them into shadow. It is a stroking light which flatters by attending to the shapes on which it falls.

The effect of the evening light on the little ruined house is interesting. It is set much more certainly within its neighbouring landscape than it would have been earlier in the day. Imagine this scene without the swell of the landscape revealed. The house would be set adrift in a sea of fields. You wouldn't in some senses know where it was, and any loss of information is a loss to the photograph.

Film: Ektachrome 64 ASA
Camera: 6 x 6 centimetres
Lens: Telephoto
Exposure: 1 second at f.32
Filters: Polarising

POINTS TO WATCH

● *The light and shadow in the foreground share the quality of light and shadow in the distance. On the principle of always explaining as much as you can, it is always worth trying to reproduce in the foreground what is happening in the distance. Imagine a foreground entirely bathed in shadow. The picture would have become quite unbalanced.*

● *It is lucky that there is a greyish sky. A fierce blue sky would have stolen the show from what was happening on the ground.*

45

The Dramatics at the End of the Day

CHATEAU CHAMBORD, LOIRE

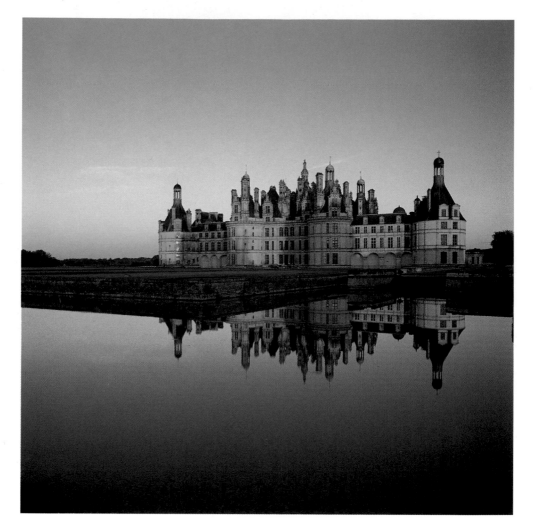

I feel a little ambivalent about Chambord. It's rather a mother-in-law of a chateau, isn't it? You might fall in love with somewhere like Azay-le-Rideau, but this is really a little too much, the architecture of the really fulsome *embonpoint*. Nevertheless I feel sure that the men who built it must have had this photograph in mind. Coming here is like arriving in a theatre. Every decision has already been taken for you. The architects and landscapers have created a set in which the last of the sun provides the supremely appropriate lighting. The building is such an overstatement that only in the little light of evening can the vast airless bulk begin to look beautiful, the duchess at the ball, her jewels sparkling about her.

Film: Fuijichrome 50 ASA
Camera: 6 x 6 centimetres
Lens: Wide-angle
Exposure: 1 second at f.22
Filter: Polarising, half-polarised

POINTS TO WATCH

● *Shadow at the end of the day comes in very fast indeed. This, if anything, is a little too late. On the right-hand tower the dark has already climbed a third of the way up the building. With evening photography make sure that you get there in very good time.*

● *The polarising filter will take more light out of the water than the sky. With reflected buildings this works well, framing the reflection you want by killing the reflections in the foreground.*

ALBI, TARN

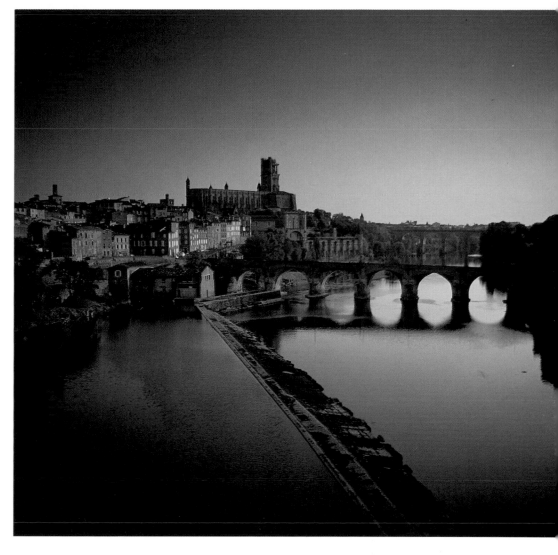

I arrived at Albi at the end of a long day. I was not interested in taking a picture here: there was no light left to speak of; and I had switched off, thinking only of somewhere to stay. And then this. I was caught unawares by it, by the city presenting itself at its absolute best.

Light can lie. Albi is not on the whole a very attractive town, but light as theatrical as this is so seductive and flattering that no human being would be allowed to get away with it. But the photographer is in a position to use all the cosmetics of evening light to make a place seem astonishing.

The light here is so directional, and there is little of it, lighting only the best part of the houses – the river frontage – so that, oddly enough, more prominence in the picture is given to those houses than to the cathedral. The shutters add a little tang. And the light under the arches of the bridges helps.

Film: Fujichrome 50 ASA
Camera: 6 x 6 centimetres
Lens: Wide-angle
Exposure: 1 second at f.22
Filters: Polarising, fully polarised; 81c warm-up

POINTS TO WATCH

● *Perhaps the polarising filter has been over-used here. The bottom left-hand corner has lost all glow.*

● *81c warm-up filter I think was also over-used here. It should not be quite so red.*

Lenses

The lens is the medium through which the landscape reaches the film and almost nothing shapes a picture more radically than the choice of lens. The chapter discusses how and why standard, wide-angle and telephoto lenses might be appropriate in different situations.

THERE IS RARELY a question in my mind, when faced with a scene like this, about which lens to choose. It was obvious to me that only a wide-angle lens would make true sense of this seaside town. Why? Partly because the whole picture depends on the relationship of the promenade to the steps in front of them and any lens which was not wide enough would have cut that relationship in two. And to have done that would have been a waste of the marvellous tide-dampened sweep of the stepped seawall, which has something about it of the underside of a scallop shell.

The lens has also had the effect of making the promenade into quite an abstract picture. That is helped by the near-monochrome of the colours here, but also by what might be called the geometry of colour in it, the way in which the enormously wide 'arrows' of white houses, black steps and then the paler surface of the wet, light-reflecting steps, all diminish so sharply from the foreground to the disappearing point precisely in the centre of the picture. (It is significant, incidentally, that if all the steps had been wet and equally reflective, the picture would have lost a great deal of its impact. It needs that banding of black, white and black.)

None of this drama of recession would have been in the picture without using a wide-angle lens. A longer lens would have compressed and flattened the scene, clipping away the edges of the foreground and turning something that here I think looks dramatic into a dank and dreary morning on the north coast of Wales.

48

LLANDUDNO, GWYNEDD

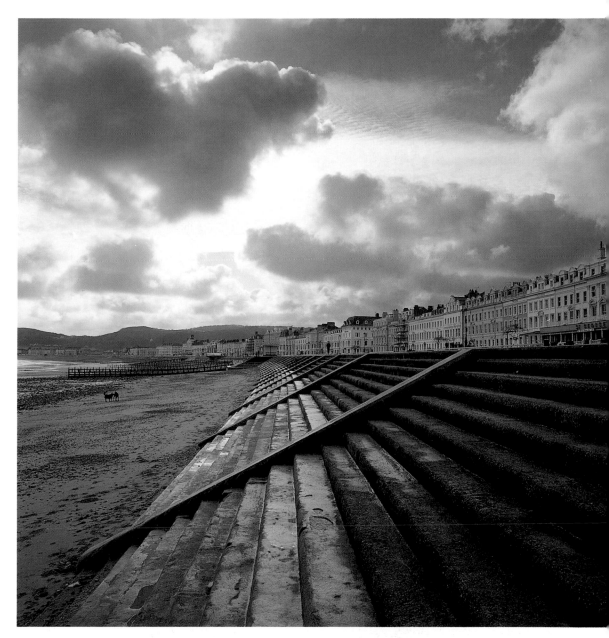

Film: Fujichrome 50 ASA
Camera: 6 x 6 centimetres
Lens: Wide angle
Exposure: 1 second at f.32
Filter: Low-density grey-graduated

° POINTS TO WATCH

● *Watch out for flare in a backlit picture like this. Shield the lens with your hand or a hood but be careful that neither appears in the frame.*

● *If you are trying to include as much of a scene as possible – which can be the only justification for using a wide-angle lens – then it is vital that everything in the photograph is sharp. You need absolute maximum depth of field which means a long exposure. Make sure that the tripod is rock-steady and that the horizon is even.*

● *Moving traffic would have spoilt the picture. If there had been a bus driving along the promenade, it would have here appeared as an ugly blur. Wait until there is no traffic, or better, as I did here, get up early. This was taken at about 7 am.*

The Better Picture

SOUTHWOLD, SUFFOLK

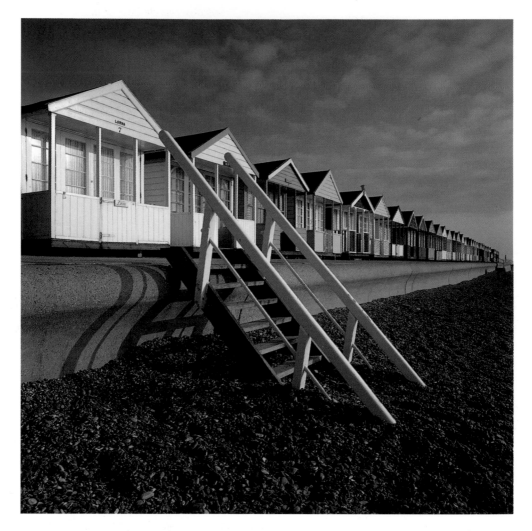

I was faced with this wonderful English scene. Southwold always seem to me stuck in 1956, and the row of all-too-English beach houses, stretching from here to eternity, cannot have changed for decades. How to photograph it? I started with the picture on the opposite page, well back on the beach with a wide-angle lens to take in the full length of the subject. But it is not a success. The graphic elements are too weak, the sky is a failure and there is far too much uninteresting and uninformative beach. The first instinct had been the wrong one.

I could simply have changed the wide-angle lens for a telephoto and come up with a picture something like the one above. But the following things would have happened.

> Film: Fujichrome 50 ASA
> Camera: 6 x 6 centimetres
> Lens: Wide-angle
> Exposure: 1/2 second at f.22
> Filters: Polarising, fully polarised, 85 warm-up

The beach huts are above the level of the beach and I would have had to point the lens up and the verticals in the photograph would have begun to converge. The only way to have avoided that would have been to have climbed up a tall ladder. With a long lens it would also have been unlikely that the whole strip of beach huts would have been included in the frame.

The conclusion was obvious; I had to walk with the cameras and the wide-angle

lens up to the the beach huts themelselves. Only then would I get both the large graphic shapes and the full length of the row.

● *In the close-up it is important to make sure that the verticals remain vertical. Do not tilt the camera up.*

● *Make sure you keep the whole row of huts in the picture opposite. Any slight movement even of one millimetre would have spoilt the composition. After each exposure check that the camera hasn't been jogged and the composition disrupted.*

● *In the close-up, the white hut dominates the picture too much. It would have been better halfway down the row of huts. At the moment its huge white bulk doesn't allow the other huts their full part. But the placing of the steps dictated this choice of position. Only here could they have had their full graphic impact. The warm-up filter is used here to reduce the white.*

● *The picture below could have been improved by cropping off the right-hand edge so that it just touched the end of the beach houses.*

> Film: Fujichrome 50 ASA
> Camera: 6 x 6 centimetres
> Lens: Wide-angle
> Exposure: 1/2 second at f.22
> Filter: Polarising, fully polarised

SOUTHWOLD, SUFFOLK

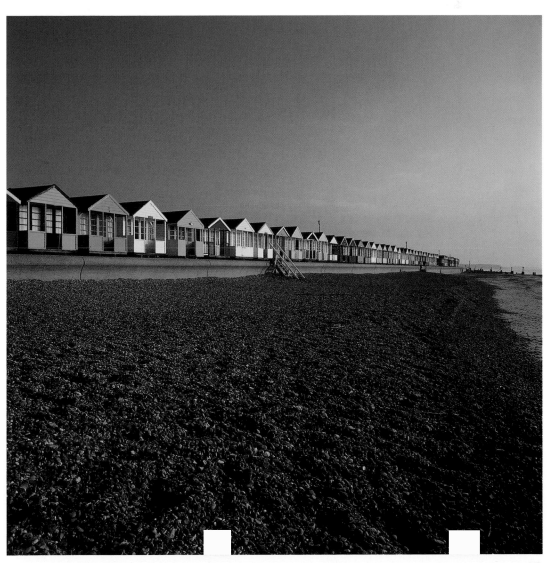

The Broader Space

SIDMOUTH, DEVON

This is not the scene that the people walking along the beach would have recognised. It was a bright day, not this strange and gloomy picture. But I knew I wanted to photograph the extraordinary mercury sheen on the wet beach and everything followed from that. It was clear that only a wide-angle lens would do. Always remember that a wide-angle lens works vertically as well as horizontally, bringing the photograph almost up to the feet of the photographer, so that in the reflections of the beach you are in effect photographing a large section of the sky. But it was necessary to bring down the light intensity of the sky to the level of the reflections on the beach. I had to put on two grey-graduated filters, a high- and a medium-density, to darken the sky sufficiently.

The result is that a sunny day is changed into something like a brightly lit storm. The fierce brightness on the sea is a necessary point of highly dramatic lighting, like the single point of light in the eye on a portrait, and the dark bulk of the cliffs anchors the whole composition. A standard lens could not hope for this effect, with a long lens you would not even have known the beach was wet.

Film: Fujichrome 50 ASA
Camera: 6 x 6 centimetres
Lens: Wide-angle
Exposure: 1 second at f.22
Filters: High-density grey-graduated and
medium-density grey-graduated

POINTS TO WATCH

● *The graduated filters have unfortunately cut into the top of the cliffs, overdarkening them.*
● *Check your horizon. Use a spirit level. An unstraight horizon would ruin a picture like this.*
● *When the sun is very low and you are photographing almost directly into it, flare – the result of sunlight falling directly on to the lens – is a danger. It could be that you will be forced to tilt your camera down and forsake your original intentions.*

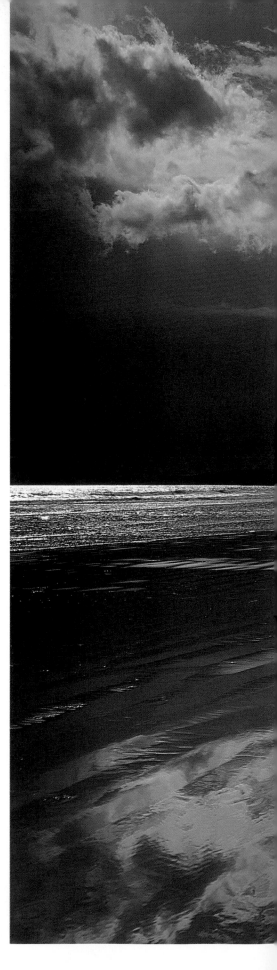

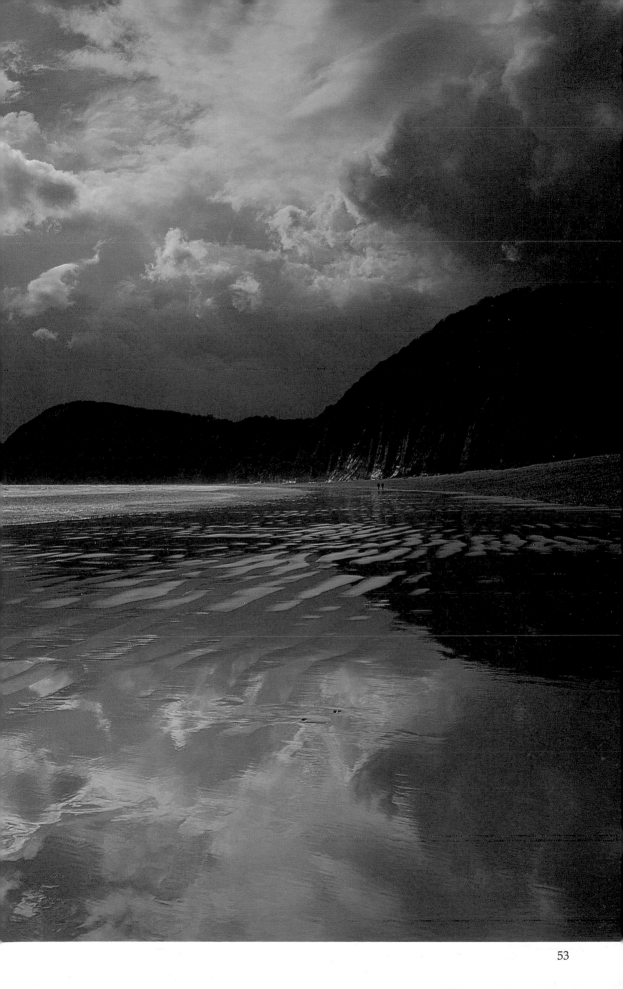

Finding the Other Picture

Near Logrono, Rioja, Navarra

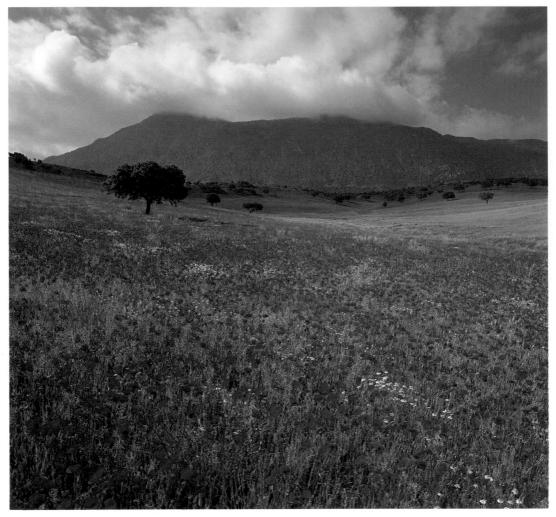

There is always more than a single picture in a place. The temptation to include as much of this field of poppies as possible was almost overwhelming. It is the sheer spread of them that is so miraculous, the generous explosion of the natural world that they represent, set against the severe backdrop of the mountain in the distance. I wanted to make all I could of the colour of the poppies but to avoid the over-pretty effect of a deep blue sky. The combination of polarising filter, to raise the colour of the poppies, and grey-graduated filter to lower the intensity of the sky, works very well.

Much as I love this picture, there seemed to be something lurking in the landscape which it did not quite capture; the contrast between the harshness of the grey mountain and the richness of the meadow below it.

Film: Fujichrome 50 ASA
Camera: 6 x 6 centimetres
Lens: Wide-angle
Exposure: 1/2 second at f.22
Filters: Polarising, low-density grey-graduated

POINTS TO WATCH

● *For sharply defined foreground detail use a wide-angle lens.*
● *At slow shutter-speeds, any wind will blur flowers and grasses. Wait for a lull.*
● *To avoid under-exposing the middle distance, do not bring the grey-graduated filter too low. The top quarter of the picture is sufficient.*

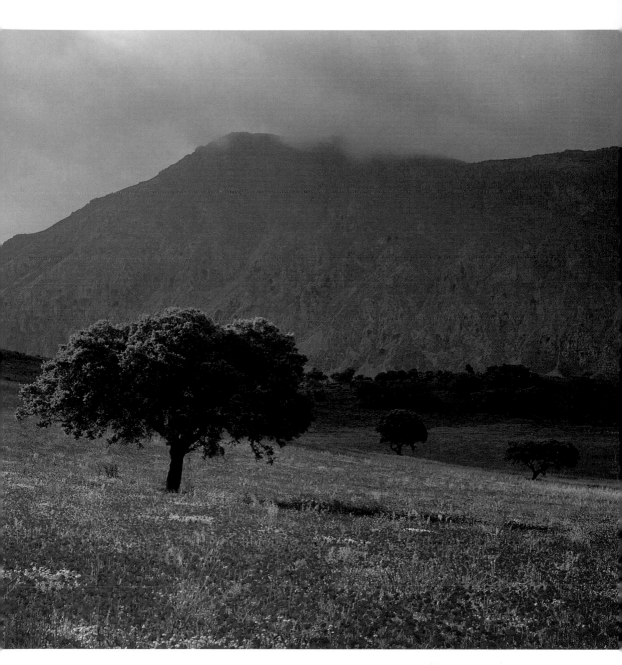

A combination of waiting for the light to play over the scene in front of me and a change of lens produced this second image. I did not move the tripod a single inch.

A band of sunlight stripes the middle distance between the tree and the mountain. Both background and foreground are in shadow, so that the colour of the flowers is enriched by being slightly underexposed. The effect of a long lens is to bring the background closer to the foreground, so that the picture assumes a more concentrated form.

Its relationship to the longer view is clear; its impact could not be more different.

Film: Fujichrome 50 ASA
Camera: 6 x 6 centimetres
Lens: Short telephoto
Exposure: 1/4 second at f.22
Filters: Polarising, low-density grey-graduated

POINTS TO WATCH

● *A long lens can result in possible loss of resolution in the foreground. Ensure the smallest possible aperture for maximum depth of field.*
● *With a long lens, the possible depth of field is always reduced. Use a small step-ladder to get as high as possible above the foreground.*
● *The longer the lens, the less the definition.*

Excluding Distractions

KANONI, CORFU, GREECE

KANONI, CORFU, GREECE

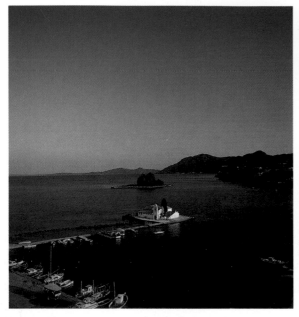

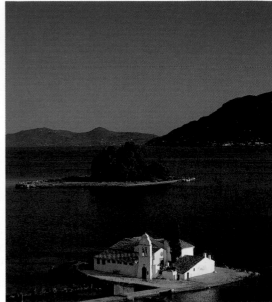

It is quite clear which of these three pictures works the best: the one taken with the longest lens on the page opposite. The first, above, taken with the wide-angle lens, is weak because the information in every area of the picture is not strong enough to give it shape. The boats distract from the monastery and the monastery from the boats. It is too much of a 'scene', where a piece of this and that are tossed into the frame without any real care. Neither the root of the main jetty nor the jetty on the right hand side to which some further boats are moored are shown in this picture. It is a picture of incompleteness, an unshapely photograph from which elements have to be excluded to make it work.

The slightly longer lens is an improvement but it still doesn't work because the monastery, which is such a pretty building, demands to be seen more than it is shown here, because the sky continues to be boring and because the hills behind are poorly defined. This too is not yet a picture.

There is also a structural problem in that the island in the background competes with the monastery island for a dominant role in the picture so that one is left asking: what is this picture about?

Film: Fujichrome 50 ASA
Camera: 6 x 6 centimetres
Lens: Short telephoto
Exposure: 1/4 second at f.16
Filters: Polarising, 81d warm-up

Film: Fujichrome 50 ASA
Camera: 6 x 6 centimetres
Lens: Wide-angle
Exposure: 1/30 second at f.8
Filters: Polarising, 81d warm-up

POINTS TO WATCH

● *Try not to cut boats in half as I have done here. Keep all the edges of a picture clean.*
● *When the sky is dull consider a photo that doesn't involve so much of it. An expanse of cloudless sky kills a picture*

POINTS TO WATCH

● *Consider the balance between the two islands. It would have been better if the far island was more to the left and the foreground island more to the right. To achieve this, I would have had to hover in mid air.*
● *Notice how in the bottom left of the picture the mast of a boat protrudes unexplained into the picture space. Always try to avoid unwanted intrusions like this.*

The intense focus on the building with the long lens is the best. At last the one interesting thing in the picture is given its say. Even so here a little clipping of the edges of both the islands is annoying. I could perhaps have come in even closer with a longer lens but then the monastery would have been utterly removed from its context – a large part of its attraction lies in its island site – and the building would have been cramped. It is still not a completely pleasing picture, but this is a case where a long lens, simply by excluding the irrelevant, can transform a diaster of a photograph into one which at least has a certain allure.

Film: Fujichrome 50 ASA
Camera: 6 x 6 centimetres ce
Lens: Telephoto
Exposure: 1/2 second at f.22
Filters: Polarising, 81d warm-up

POINTS TO WATCH

● *Make sure when using a long lens that, for example, the little red boat here is not cut out. It provides the necessary bright pimple.*
● *It is important that there is no movement of wind or people. The meaning of the picture has to be still evening reflection, escpecially at this magnification. With a shorter lens, more 'noise' would have been livable with.*

KANONI, CORFU, GREECE

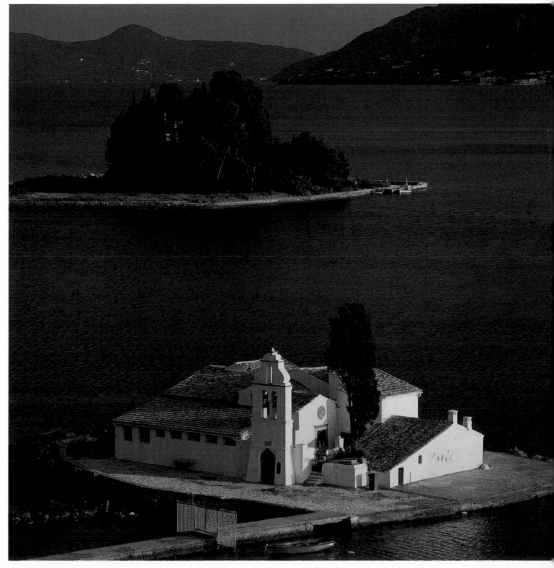

Movement and Exposure

A photograph is still and elements of the landscape are often mobile. That essential condition of the art means that decisions have to be made. Do you want to still the movement, wait for no movement or allow part of the picture to be blurred, either through the movement itself or by using a shallow depth of field? The chapter shows both the subtle and the extreme effects that changing the exposure can have.

I HAD A STRANGE and revealing experience with this photograph. It was on show in a gallery as part of an exhibition. An old lady with a monocle stood in front of the picture, had a good look at it and said, 'What a wonderful painting! Are you the artist?' I said I was.

It is worth asking why this picture seems to be such a painterly thing. First of all, it is to do with the quality of the light. I arrived here before the sun had come up; this is a photograph of the true light of dawn. The mist is going away and the colours are softened by the diffused light coming not from a single source but from the whole expanse of sky.

The low light required a long exposure and the absolute stillness of the reeds in the foreground, standing in the water as though they are painted one by one. It would not have been possible to have them like this if there had been any wind. Here is the essence of the still photograph.

There is something magical about this stilled stillness. It is a double effect, like cream poured over cream cheese, as though the landscape was existing already in the state of a photograph and the function of the photographer was to do no more than open his shutter and let the picture flood in. Of course, nothing could be further from the truth! Exquisite stillness demands even more control than usual. There could be no shooting off here. But precision picture making is the aspect of photography that gives me the most lasting pleasure.

RYDAL WATER, CUMBRIA

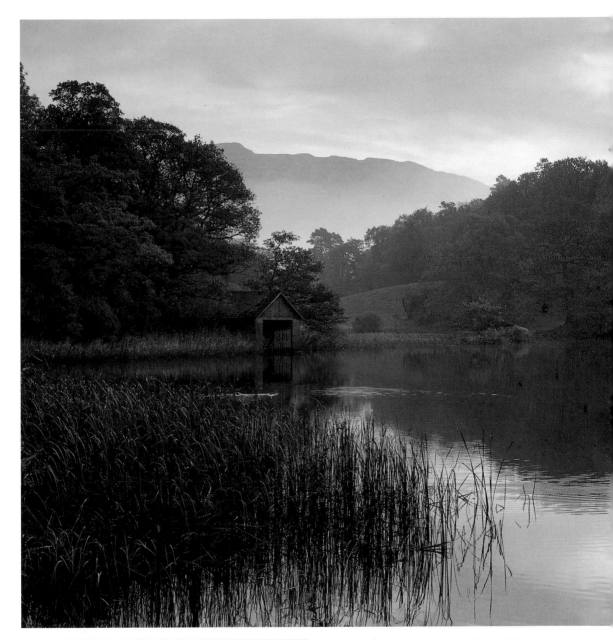

Film: Ektachrome 64 ASA
Camera: 6 x 6 centimetres
Lens: Wide-angle
Exposure: 1 second at f.32
Filters: None

POINTS TO WATCH

● The structure of the picture is a series of layers which move back into the picture: the reeds, the shadow on the water, the trees on the left, the far woodland and finally the mountain in the distance, its base hidden by mist. The contours of these elements all droop in from the edges of the picture towards its centre, where the eye settles on the boathouse, the only sharp-edged object in the whole scene and its discreet if necessary focus.

● The photograph was taken on top of a stepladder. If I had been standing down at lake-level, very little of this, particularly in the foreground, would have worked: the reeds would not have been framed by the patch of lit water; the boathouse itself would not have been clear of them; and the patterning of successive layers in the picture would have been fatally compressed.

Frozen Motion

VAL D'AMPOLA, LOMBARDY

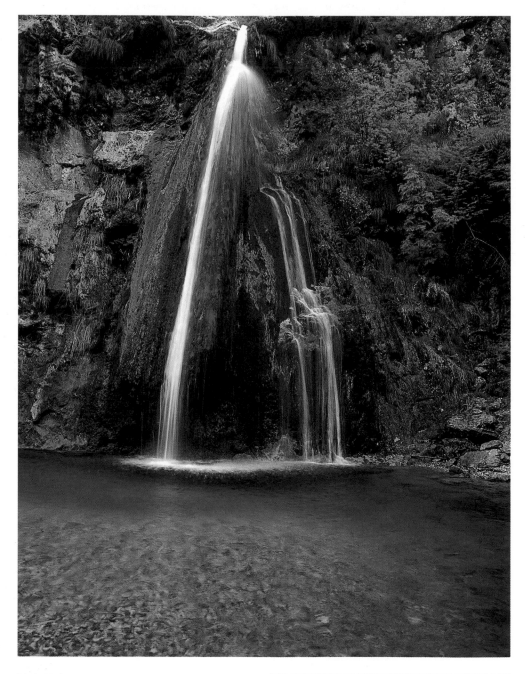

With moving water you have got a choice, you either freeze it or let it run. If you want to still water you have to use an exposure of not more than 1/30th of a second. But there is a lot to be said for allowing the movement in the water to appear in your frozen image of it. Time-blurred water has something of time buried

Film: Fujichrome 50 ASA
Camera: 6 x 6 centimetres
Lens: Wide angle
Exposure: 2 seconds at f.32
Filters: None

within it. But once you have decided to let the water move while the aperture is open, then you must decide how much are you going to let it run. How long an exposure do you want to give it? It is almost impossible to know at the time what the effect of a particular exposure will be on the water, but in general one or two seconds for fast flowing water is about right, depending on the lighting conditions. If you leave it a great deal longer than that, you are in danger of ending up with nothing but a white woolly blur which wouldn't look like water. Always leave yourself with the choice afterwards, so bracket your exposures either side of one second. Two exposures under and two over will leave you with a sequence of photographs each achieving a slightly different effect.

Film: Fujichrome 50 ASA
Camera: 6 x 6 centimetres
Lens: Short telephoto
Exposure: 2 seconds at f.32
Filters: None

ARAN VALLEY, LERIDA, SPAIN

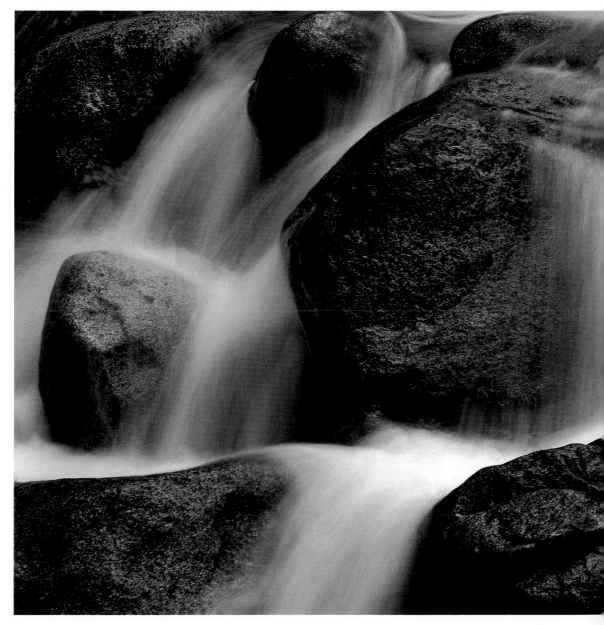

Depth of Field

WEST OF GUADALUPE, CACERES, SPAIN

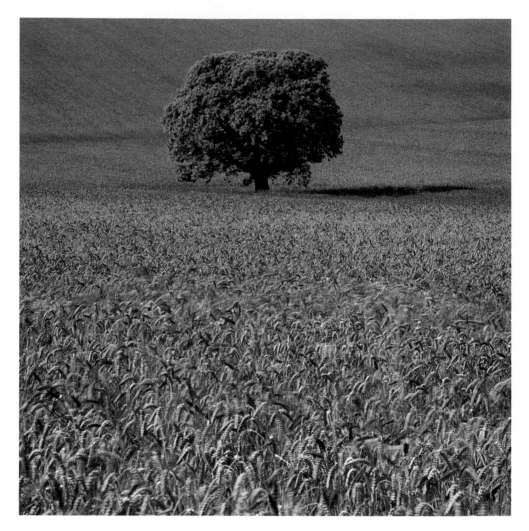

I wanted to compress the scene, so that the tree played a large part in the picture. I couldn't get any closer because of the standing wheat in the field and so I had to use a very long lens. But the depth of field in a long lens is very small. To maximise it the smallest aperture had to be chosen. A very long exposure was necessary to compensate. Had there been no wind, this would have been no problem, but two seconds allows wind to make itself felt and show its effect on a picture. So you can see in the picture where the wind has blown the ears of the wheat. Does this matter? Not in the background where there is little or no definition, but the delicate nature of the ears of wheat in the foreground is spoiled by the wind. Or is it?

Perhaps you could see it in another way: do the blurred ears of corn represent the nature of a wheatfield in the wind better than an absolutely still picture would have done?

Film: Fujichrome 50 ASA
Camera: 6 x 6 centimetres
Lens: Telephoto
Exposure: 2 seconds at f.45
Filters: None

POINTS TO WATCH

● *Any intrusion into this picture would have upset its balance – a bit of another tree or the edge of the field would have ruined it.*
● *With an isolated tree, be sure never to cut into the shadow.*

EAST OF MERE, WILTSHIRE

Again a logical sequence takes place in your mind. You want good colour saturation in the picture and to get that you have to use a slow film. Equally, you want to make sure that the poppies in the foreground and the trees in the distance are all completely sharp. You need in other words maximum depth of field. Such clarity from the back to the front of a photograph can only be achieved with a small aperture. And if the aperture is very small and the film speed is very low, the exposure time has to be long. You therefore need a very good tripod, a stable platform on which the camera can rest unmoving while the diaphragm is open.

If these steps are not followed the result would be blurred poppies and grass in the immediate foreground. Why would that be displeasing? Perhaps because you wouldn't know what it was. You don't want a red splodge where a poppy should be.

Film: Fujichrome 50 ASA
Camera: 6 x 6 centimetres
Lens: Wide angle
Exposure: 1/2 second at f.22
Filters: None

POINT TO WATCH

● *I should have pulled out the dandelions. and removed the white rocks leaning against the base of the tree in the middle distance on the right. Light coloured details distract.*

Allowing a Hint of Movement

KOKALA, SOUTH OF YITHIO, MANI, PELOPONNESE

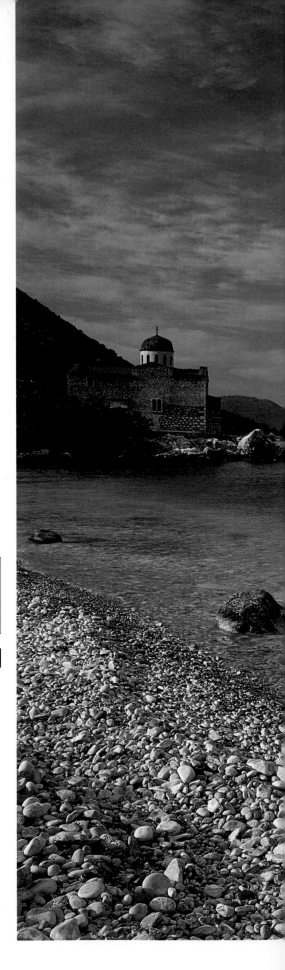

You might imagine that this is a completely still scene, in which nothing ruffles the placidity of the landscape. But the long exposure has allowed a hint of movement to remain in the swirling of the water next to the beach. I don't think you would notice it if it were not pointed out, but it has had two important effects on the picture. The first is that there are no sharp edges to the breaking ripples as the wavelets approach the beach. The serenity of the distance and the absolute calm of the horizon are not interfered with by the any surface 'noise' in the foreground. And secondly, by allowing the water above the patches of green weed to swirl around for half a second, the area of green in the picture has been increased. Without those beautiful, and enlarged, patches of colour, the photograph would have been diminished.

Film: Fujichrome 50 ASA
Camera: 6 x 6 centimetres
Lens: Wide-angle
Exposure: 1/2 second at f.22
Filters: Polarising, 81c warm-up

POINTS TO WATCH

● *The stones underwater can only be seen because the polarising filter has taken reflections away. This is important because without the polarising filter it would have been much more difficult to see underwater in the foreground.*
● *The warm-up filter was not quite strong enough. The white stones on the beach are leaning towards the blue.*

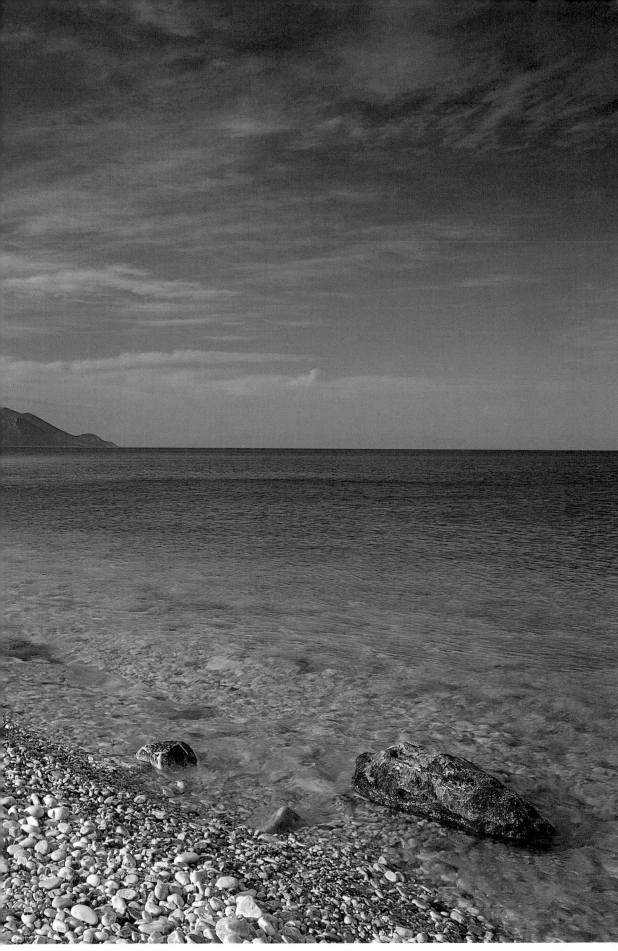

The Presence of Time

CHESIL BEACH, DORSET

These two pictures are of exactly the same place and taken one after another. The only real variable is the length of time the film was exposed. The short exposure on this page has had various effects. The true colours of the beach, sea and sky have been registered by the film and the movement of the water has been stilled

In the foreground you will also notice that the shingle is out of focus. It was a very dark day and the film I had in the camera was a slow one (50 ASA). I needed to have a short exposure to still the water and so had to use a very wide aperture of f.5.6.

An aperture of f.11 would have been better for depth of field, but there was insufficient light and I had to compromise. I could of course have used a faster film but for the long exposure which I was planning to make next, that was the last thing I wanted. The slower the speed of the film, the easier it is to make a long exposure.

Film: Fujichrome 50 ASA
Camera: 6 x 6 centimetres
Lens: Wide-angle
Exposure: 1/30th second at f.5.6
Filter: Medium-density grey-graduated

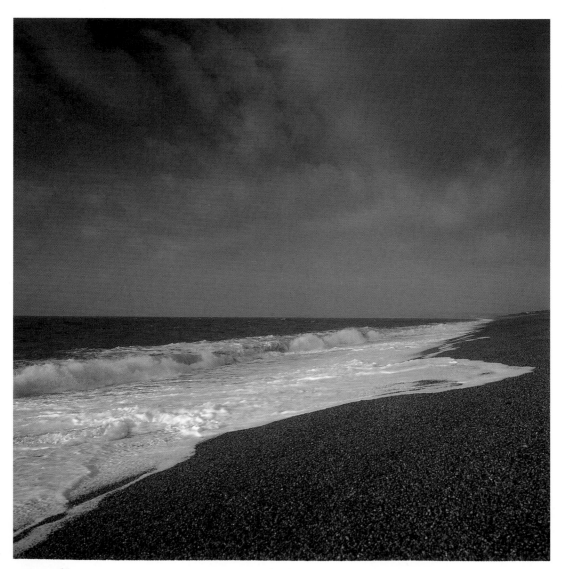

CHESIL BEACH, DORSET

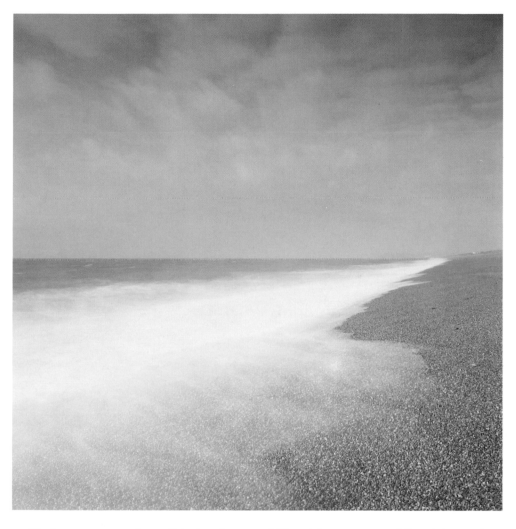

The long exposure above distorts colour and creates a strange and ghostly image as the surf washes back and forth across the shingle. It is in its way alluring if quite obviously unreal. This is the sort of effect which you might like to go for if you are thinking of setting a weird or romantic figure in the landscape. This is something I almost never do myself, but it is always good to know how to achieve an effect which you then might deliberately never use.

In order to reduce the amount of light coming on to the film two neutral density filters were sandwiched together in front of the lens, so that four times as much light was needed to expose the film as was needed in the first picture. Without them the frame would have been four stops over-exposed.

To add to the spooky effect, I have deliberately over-exposed the picture, using a 16-second exposure. If I had wanted to have the same density in the long-exposure photograph as in the one opposite, the settings would have been 8 seconds at f.22.

Film: Fujichrome 50 ASA
Camera: 6 x 6 centimetres
Lens: Wide angle
Exposure: 16 seconds at f.22
Filters: 2 two-stop neutral density (light-restricting)

POINTS TO WATCH

● *The 16-second exposure has altered the colour of the image. If you want to avoid this effect and maintain the natural colours, the film manufacturers always recommend appropriate filtration to prevent this when long exposures are made. Look at the instructions in the box of film.*

Manipulating the Image

The many kinds of filter and films of different speeds are all necessary tools of the trade. They represent the most manipulative side of landscape photography where it is not a question of responding to the landscape but of reshaping it according to your own aesthetic dictates. The chapter shows the ways in which they can be used and abused.

THIS BEECH AVENUE in Dorset in midwinter, when all leaves have fallen and the beautiful grey of the trunks and long reaching arms of the trees, reveals itself as a thing almost more beautiful than when clothed in leaves. This photograph has manipulated the natural appearance of the avenue in two ways. I used very fast film to create a grainy effect and then softened that with a soft-focus filter. I hope that, if you didn't know to look for these effects, you wouldn't know that they were there. This, you would imagine, is simply a photograph which has about it an air of winter: rubbed down and cold. All that has been achieved by manipulating the image.

Most people think of fast film as useful in stopping movement. That is how sports photographers use it, but there is no reason why you shouldn't make use of it as I have done here for a static subject. Winter is never this colourless. It is the fast film, with its very low saturation, that has drained the colour out of the grass and bark.

And then there is the question of a soft-focus filter. It is something I use very rarely and it has acquired a very bad name through clumsy and exaggerated use. But I do think there is no need to be too precious about the use of photographic tools like these. To use a soft-focus filter does not necessarily mean that you have a gooey-eyed attitude to nature. It can be used, as I hope it is here, to reveal a beautiful if soft-edged aspect of the natural world.

NORTH OF WIMBORNE, DORSET

Film: Agfachrome 1000 ASA
Camera: 6 x 6 centimetres
Lens: Short telephoto
Exposure: 1/30 second at f. 22/32
Filter: Soft-focus

POINTS TO WATCH

● *The picture doesn't need any sky, because it is about the canopy of branches, the overfolding of trees and the relative lightlessness of a winter day. Never think that sky has to be in a landscape photograph. Only include something if it adds to the picture. Omit the redundant.*

● *Even in these conditions always try to get a good depth of field. Out of focus grain does not look the same as grain that has been softened by a filter.*

69

Enrich the Colours

KNOWLTON, DORSET

A polarising filter has two functions: it increases colour saturation across the whole picture, cutting out the white light reflecting from leaves, grass, walls and so on, allowing the true colour of the surface to shine through. It also has the effect of darkening a blue sky and as a result making the clouds more pronounced. It works at its most efficient when the sun is at right angles to the lens, i.e. to the right or left of you. When the sun is immediately ahead of or behind you, the polarising filter has little effect, simply because most of the light rays are coming straight at the camera.

This pair of photographs shows how very subtle indeed the effect of a polarising filter can be. The blue of the sky is slightly deepened, the clouds stand out a little more, the grass has a slightly richer colour, the textures of the rough bank in the foreground are lifted and as a result the whole picture

Film: Fujichrome 50 ASA
Camera: 6 x 6 centimetres
Lens: Wide angle
Exposure: 1/2 second at f.22
Filters: None

POINT TO WATCH

● *The sky here is a little bit messy, a fuss of clouds, neither one thing nor another. Another day might have been better, but in these conditions, where you have to pull out the stops, the polariser can give life to a picture which needs it.*

gains in substance and a sense of tangible reality. The polarising effect doesn't have to smack you between the eyes, although it often can. There are many occasions when it can make the blue of the sky too deep and sickly and this has to be guarded against. Where the sky becomes solid with colour it can completely overwhelm the landscape, which is never the required effect. For this reason, it is almost always a mistake to use a polariser when the sky is all blue. In those conditions consider half-polarising, turning the filter half a revolution, so that the sky acquires substance without garishness.

There is also another danger with a polariser which is difficult to avoid but almost never looks good in a photograph. The filter has a tendency to darken the corner of the sky which is furthest from the sun, but allows the sky to grow pale as it approaches the source of light. This is a recipe for imbalance and an unattractivce sky. You can sometimes adjust this, although it does not always work, by setting a medium-density grey-graduated filter over the corner of the frame which is nearest the sun.

Film: Fujichrome 50 ASA
Camera: 6 x 6 centimetres
Lens: Wide-angle
Exposure: 1 second at f.16/22
Filter: Polarising

POINTS TO WATCH

● *Remember the polarising filter cuts out a great deal of light, the very reflections whose purpose it is to remove. When using it, increase the exposure by 1 1/2 or 2 stops.*
● *Buildings do not look so good when the light is right behind the lens, because there are no shadows. Try to have the light striking the building obliquely.*

Warmth

HOLNEST, DORSET

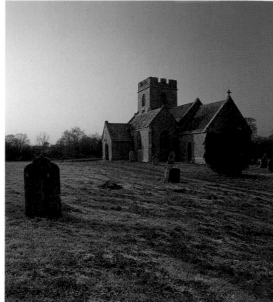

Film: Fujichrome 50 ASA
Camera: 6 x 6 centimetres
Lens: Wide-angle
Exposure: 1/4 second at f.22
Filters: None

Film: Fujichrome 50 ASA
Camera: 6 x 6 centimetres
Lens: Wide-angle
Exposure: 1/4 second at f.22
Filter: 81a warm-up

The 81 series of light-balancing filters are useful for the way in which they can give an overall cast to a picture. The point of them is to turn the picture away from the blue end of the spectrum and towards the yellow. To put it more simply, they add warmth.

The effect of the series on a single scene is shown on these pages. Here in the first picture is an English country churchyard on a winter afternoon without any colour balancing filter in action. The frost is going too blue, especially in the shadows. It is difficult to register the differences between this and next picture, but if you flick your eye back and forth across these four pictures, you will see the effect of the 81 series. Something slightly off-putting or resistant in the unfiltered picture is almost invisibly removed. The blueness of the original image is 'cold' almost in an emotional sense. The fact that this is a photograph of a day which is physically cold makes an interesting point. The sense of physical cold is not

diminished in the filtered photographs. It remains a frosty day throughout. But the photograph becomes more inviting, it becomes emotionally warmer.

Many photographers leave the 81a filter permanently on the lens as they prefer a warmer feel to their photographs. Its effect is slight but can be seen especially in the sky to the left of the church and in the light falling on the church walls themselves. It is a very subtle effect which you wouldn't notice if you didn't know the filter was there. It is almost as if you have added twenty minutes or so to the light of an evening. This might well be the source of its reality effect. You have no idea when this photograph was taken and the light cast by the filter is a perfectly likely sort of light to find late on a winter afternoon. The fact that it is 'untrue' matters far less than the feeling that it might be true.

There is an 81b warm-up filter but its effect is very similar to 81a and so we jump

here to 81c. I think this is the most pleasing of all because its effect is quite definite but it is not trying to suggest a completely different light. It is just adding a touch of warmth, just about the right amount, so that the feeling is warm and friendly, the kind of place where you might like to find yourself.

The use of a filter will depend on what the light conditions are at the time. If the light is already very yellow then it may be that even an 81c may tip the scales of 'reality' just over the point of balance and you may have to make do with an 81a or 81b. It is, as ever, a question of remaining sensitive to the conditions at the time. Respond to what is happening.

Again, there is an 81d warm-up filter, which is halfway between 81c and 81ef. The effect of the ef is to give more of a sepia cast to the whole scene. It is quite noticeable in the finished product that you have altered the light to achieve an effect. I would not use this very often myself because it puts too conspicuous an overall cast on to the picture. Here, for example, the blue over most of the sky has been replaced by

something approaching yellow. The secret of good filter use is for the filter to be unnoticeable. And here the picture is certainly veering in the direction of an obvious effect. It is nothing like the way in which the 85 and 85b warm-up filters can reconstruct the scene (see overleaf) but this sepia colour is not quite what you would expect in a real scene. This is, however, a marginal question and in some circumstances the effect of an 81ef can be, as it needs to be, subliminal.

POINTS TO WATCH

● *Using an 81c, 81d or 81ef warm-up filter has the effect of reducing the light coming into the lens by half a stop. You should adjust your exposure to compensate for this if you are using a hand-held exposure meter. If the camera uses a through-the-lens exposure meter, then you have no need to make the adjustment yourself. The camera will do it automatically.*

● *Notice how the 81ef has started to turn the yew tree at the east end of the church almost red. This is an example of the unwanted oddness which filters can introduce into a photograph.*

Film: Fujichrome 50 ASA
Camera: 6 x 6 centimetres
Lens: Wide-angle
Exposure: 1/4 second at f. 16/22
Filter: 81c warm-up

Film: Fujichrome 50 ASA
Camera: 6 x 6 centimetres
Lens: Wide-angle
Exposure: 1/4 second at f.16/22
Filter: 81ef warm-up

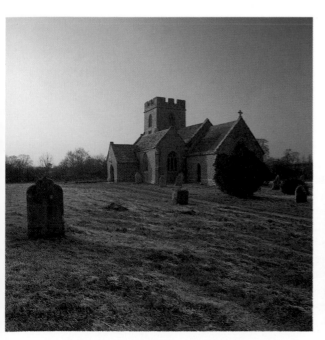
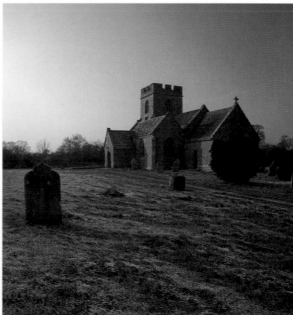

More Extreme Effects

HOLNEST, DORSET

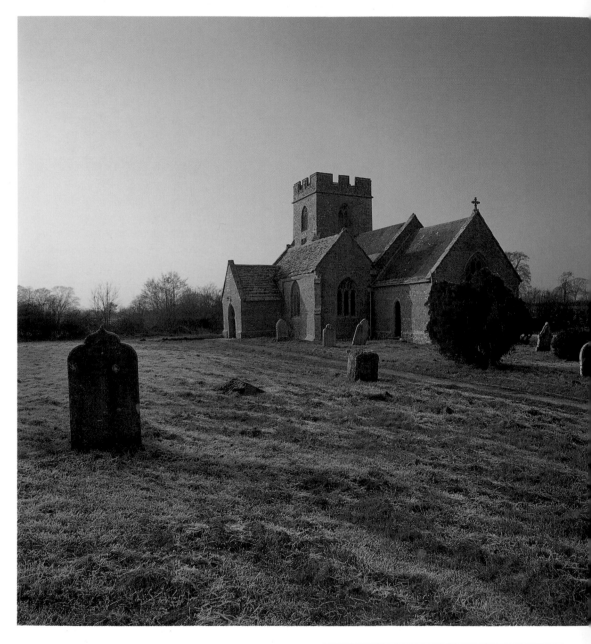

The 85 warm-up steps outside the series in that it is not an amber filter so much as a pinky yellow one. The use of these filters is always subjective and I must confess I almost never like to give this extra pinky feel to a landscape. I do not think it works particularly well here, for example, because to me it looks false, the colour cast extreme, so that there is a rather sugary sweet air to it, as if the picture had been

| Film: Fujichrome 50 ASA |
| Camera: 6 x 6 centimetres |
| Lens: Wide-angle |
| Exposure: 1/2 second at f.22 |
| Filter: 85 warm-up |

coated with a strawberry flavoured sauce. That can't be suitable to an English church-yard in winter. It is too coy for words.

The distinction between the 85b and the

81 series is that the 85b is very distinctly a sepia filter, rather than the plain ambers of the 81 series. This picture involves another confession. The 85b sums up everything in a sort of photography that I most dislike. Its caramel coating is widely used in commercial photography to give a theatrical, enriched, evening feel to a picture. But the effect somehow manages to be both exaggerated and trivial at the same time, visibly false and in no way respectful of the tone or meanings of a place. I never use it myself because it seems to me too easy and too careless a way of treating a landscape. The picture says 'Here I am, a filter in an English churchyard.' And can that be the point of landscape photography? It blurs distinctions, it places something between you and the landscape rather than revealing the nature of the place itself, it imposes the sentimental warmth of a certain vision of landscape which involves a kind of blindness to its realities. You have no need to leave home to get this kind of effect. It might as well be a photograph of the latest brown bread advertisement you have seen on TV.

POINT TO WATCH

● *The real purpose of the 85b is when you have a tungsten balance film in your camera and you want to photograph in daylight. You must convert the daylight into the sort of light produced by artificial tungsten bulbs and that is what the 85b can do. Conversely an 80a colour-correction filter, which is blue, must be used when daylight balanced film is used under tungsten light. The light from a flash is equivalent to daylight.*

Film: Fujichrome 50 ASA
Camera: 6 x 6 centimetres
Lens: Wide-angle
Exposure: 1/2 second at f.22
Filter: 85b warm-up

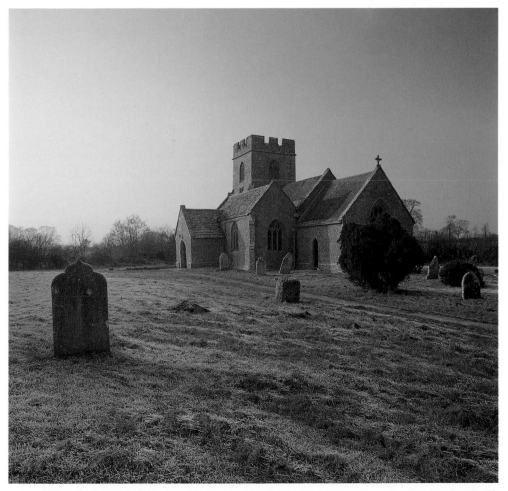

Time of Day

GUADALEST, NEAR MALAGA, ANDALUCIA

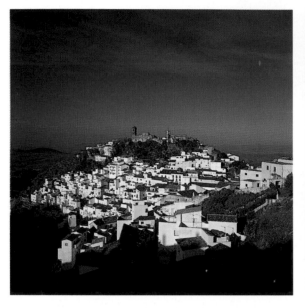 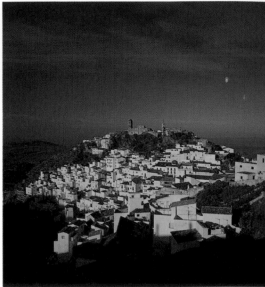

The bright geometrical elements of this hill-village in southern Spain were being cut by a sharp morning light. This first picture is almost as it appeared to the eye. Only a polarising filter has been used to deepen the richness of the sky and to bring out the beautiful wispiness of the clouds, as an effective contrast with the hard-edged shapes of the village below them.

But there is something too hard and too blue about the whites in this picture. They need the warmth of evening light to convey the full romance of a village in southern Spain.

Film: Fujichrome 50 ASA
Camera: 6 x 6 centimetres
Lens: Wide-angle
Exposure: 1/4 second at f. 22
Filter: Polarising, fully polarised

POINTS TO WATCH

● *Use a polarising filter to take the glare off the roofs and add richness to tiles and sky.*
● *Mid-morning light, in which the blue element is dominant, tends to make whites harsh and unreceptive.*
● *Beware: polarising filters will increase the contrast in photograhs, and tend to take detail out of the shadows*

You might think – I hope you think! – that I returned to the same spot the same evening and took this second picture. It is soaked in the yellow warmth of the end of the day. The blue harshness of morning has gone. Now there is something of the dreamy air of warm evening. All this is achieved with the use of a filter; the photograph was, in fact, taken a few minutes after the one on the left.

To my mind, subtlety and mildness are the key to the successful use of filters. The picture is already a failure if someone asks 'I wonder what filter he used?' A good photograph should be like a good dinner; one shouldn't be tempted to say 'I wonder how on earth the chef managed that!', but simply 'What a delicious thing this is...'

Film: Fujichrome 50 ASA
Camera: 6 x 6 centimetres
Lens: Wide-angle
Exposure: 1/4 second at f. 16 / f. 22
Filters: Polarising, fully polarised
81c warm-up

POINTS TO WATCH

● *Any filter denser than 81c(used here) would create a tangerine effect that would look artificial.*
● *Beware: green foliage under warm-up filters tends to turn yellow-brown.*

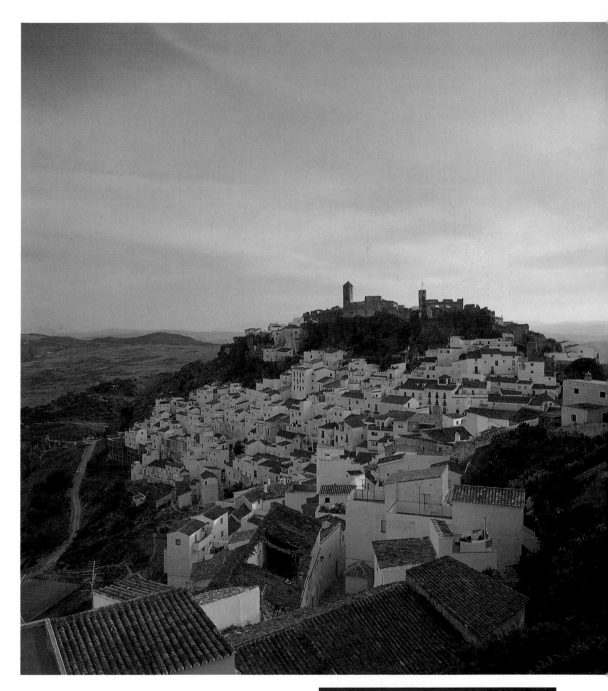

In fact, I did go back in the evening, to a slightly different vantage-point. The last rays of the sun are now coming from the right, just clipping one or two of the houses. No filters of any kind have been used here and the softness of the light is quite natural.

Film: Fujichrome 50 ASA
Camera: 6 x 6 centimetres
Lens: Wide-angle
Exposure: 1 second at f. 22
Filters: None

POINTS TO WATCH

● *Using the real qualities of the light will always produce a better image than manipulating it with filters.*

● *Wait for the reflected light of evening, with its low contrast, to achieve a warm and soft effect.*

● *Low, shadowless light allows you to achieve an even colour saturation over the whole picture. In lighting of higher contrast, the actual density of colour in the picture will vary. The effect of that will be to produce a less tranquil and more visually dynamic picture.*

The Play of Light

Use light to enhance the drama of a picture, setting the light against the dark, catching the first and the last of the light, manoeuvring the lit object aginst an unlit background. Very low light or the light in a rainstorm can bring more to a picture than bright sunshine, which often flattens or dilutes a subject. As ever, wait for conditions to come right.

A PHOTOGRAPHER has to know, care, think and learn about light as a sculptor must come to understand stone. Light is the medium, an intangible, frustrating and utterly astonishing substance, inside which the photographer has to work.

It is never still and your only task is to wait until the light begins to do for you what you hope it might. Visualise the picture as you would like it to be, which parts lit, which in shadow, and wait, almost literally, for your dreams to come true. There is no other way to go about it. Your only control over the play of light is to capture it at the moment it suits you best.

This afternoon in the Cévennes, the sky was immensely dark and heavy, with a small blue hole in it miles away to the right. The sky was moving as a body. Often in these cases the hole closes up and the moment for which you have been waiting disappears. Or the spotlight misses the place on which you want it to shine. Twenty feet here or there would make all the difference. On this afternoon I waited two hours. A wind shift would have killed it. But it arrived and caught the château where I wanted it. I took four frames in the space of 30 seconds and then it was gone, the spotlight shut off, the château returned to the dark.

That was a lucky moment. I have had many occasions when the light slid off sideways and the waiting turned out to be pointless, or at least pictureless: waiting will always allow your understanding of the place to grow.

NEAR FLORAC, LOZERE

Film: Fujichrome 50 ASA
Camera: 6 x 6 centimetres
Lens: Short telephoto
Exposure: 1 second at f.32
Filters: 81b warm-up

POINTS TO WATCH

● *In a spotlit landscape expose only for the lit areas. A general exposure will reveal detail in parts of the frame where you do not particularly want it.*

● *Midday light would have looked too blue. An 81b warm-up filter kills the blue tinge and adds warmth to the scene.*

● *Don't compromise or give up. This is worth waiting for. A photograph of the château in a different light might have looked like a postcard.*

The Layering of Light

MARSHWOOD VALE, DORSET

The layering of light is a depth-creating effect that is often used in the theatre. It can walk you right back into a picture. Here the effect is produced by the last light as it catches the ridges in Marshwood Vale in southern Dorset. The result is that you can survey the whole scene displayed in front of you.

The layers of light help the eye; they are a demonstration of depth. Imagine the valley without them. Distance would still be there but it would be a distance that was neither interesting nor beautiful. The effect here is not created by light alone: the sheep are an indispensable aid to this creation of depth; their diminishing scale is quite literally a key to distance.

Film: Ektachrome 64 ASA
Camera: 6 x 6 centimetres
Lens: Wide-angle
Exposure: 1/8 second at f.22
Filters: Polarising, fully polarised

POINTS TO WATCH

● *Be careful not to cut animals in half. It is as great a sin as cutting the head off a person in a portrait.*
● *The long exposure has blurred the animals on the far left and in the mid-distance. This could have been avoided by using a faster film, which would have needed a shorter exposure. But that would have involved a loss of definition as fast film will always produce a grainy image. This choice must lie with the individual.*

80

However often I look at this photograph of the eroded, seaweedy rocks at the mouth of the River Erme on the South Devon coast, it never loses its air of unreality – or at least its atmosphere of strange half-reality. I am not quite sure what lies behind this effect, but it is something to do with the way in which the theatrical lighting, seen in the previous picture, is doubled here: a well lit sandy apron is backed by the dark flat of the rocks; behind them again the rear of the stage is brightly lit (from a hidden light-source). The dark cloudy sky acts as the rear wall of the theatre.

ERME MOUTH, SOUTH DEVON

Film: Ektachrome 64 ASA
Camera: 6 x 6 centimetres
Lens: Wide-angle
Exposure: 1/4 second at f.22
Filters: Polarising, fully polarised

POINT TO WATCH

● *You may be able to detect places where I had walked about on the sand when trying to find the photograph here. I have tried to cover up my footprints by brushing the sand, but this is a good lesson: don't be careless about where you walk. You may be ruining the picture you have not yet noticed.*

Splashes of Light

BUTTERMERE, CUMBRIA

The splashed and lovely light in this photograph has always seemed to me beautiful for the reason that its effect seems particularly unforced. The sun is just out of the top corner of the frame and the trees are luminous from the backlighting which this gives them. There is always a danger with backlighting that light will fall directly on the lens and flare – to my mind an ugly and disruptive presence in any picture – will result. The best way of avoiding that, as I have managed to do here, is to find a patch of shade which falls directly on to the camera.

The generous feeling in the picture, as though light and shade in equal quantities have been liberally doled out all over it, comes from that rounded, almost unordered patterning of the light.

But there are other effects here too. The hillside in the background, which is in total shade, has a soft, velvety feel to it – it is lit only by light reflected off the sky and other parts of the landscape. And that movement – from the shade in which the camera stands, through the splashes of light, to the profound calm of the distant shadow is, I think, one of the reasons this photograph strikes one as beautiful.

Film: Ektachrome 64 ASA
Camera: 6 x 6 centimetres
Lens: Wide-angle
Exposure: 1/8 second at f.16/f.22
Filters: Polarising, low densitygrey graduated

POINTS TO WATCH

● *The use of a low-density grey graduated filter is necessary here to bring the brightness of the sky within the exposure range of the film. Be careful, in a picture with such a high horizion, that the dark part of the filter does not clip the tops of the hills and the tips of the trees on the left.*

● *The exposure on a windy day needs to be 1/8 second or faster to still the movement of water and trees.*

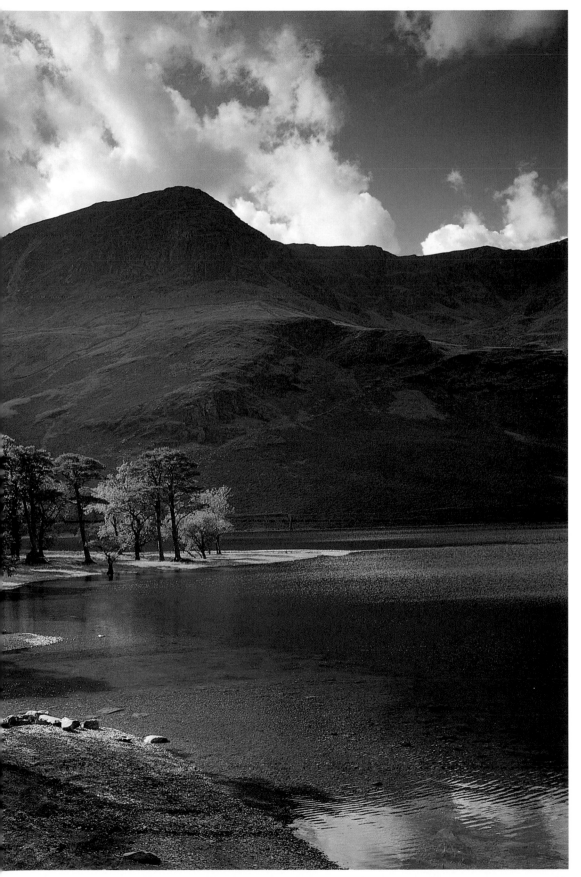

The Lit Foreground

NEAR CASTELLANE, ALPES DE HAUTE PROVENCE

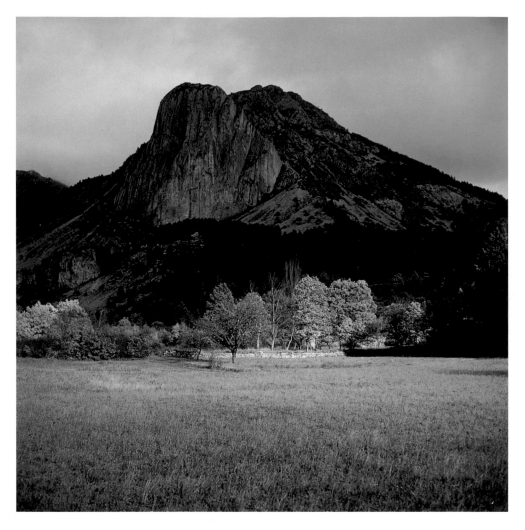

Imagine for a moment that the lighting conditions in this picture are reversed, with a light mountain and a dark foreground. The whole meaning of the image shifts because, obviously enough, light emphasises and shadow diminishes. That would have been a picture of a mountain led up to by a valley. What you have in fact is a valley overlooked by a mountain.

The light, which is low and late, is apparently sourceless but I am not entirely happy with the effect in this picture. The light on the clump of trees near the left-hand edge should not be there, nor on the great expanse of rather uninteresting grass. Better would have been a concentrated beam concentrating only on the central clump of trees.

If that had been the case, and it is in fact not far from it, there would have been a very satisfying symmetry between the lit and the dark parts of the photograph.

Film: Fujichrome 50 ASA
Camera: 6 x 6 centimetres
Lens: Wide-angle
Exposure: 1 second at f.22
Filters: None

POINT TO WATCH

● *Try putting your hand across the bottom of the picture, cutting out most of the grass. I think that improves the picture; the confrontation of hill and valley, lit and dark, is more concentrated.*

A dramatic set needs dramatic lighting and there are few places in Europe more astonishing, at least in terms of the way a building sits in the landscape, than the monasteries at Meteora. It is absolutely necessary that the monastery itself is lit. This picture was taken early in the morning and the lighting conditions are almost perfect for the subject.

Every light patch is set against a dark one. A farm in a field might demand flat light, but a monastery on a pinnacle cannot need anything but a series of highlights set against shadows.

Later in the day would not have worked. As the the sun rose, light was getting into those shadows in the rock clefts and within a few minutes one would have ended up with a pale monastery against a pale background. There would have been no picture at all.

> Film: Fujichrome 50 ASA
> Camera: 6 x 6 centimetres
> Lens: Short telephoto
> Exposure: 1/2 second at f.32
> Filter: Polarising, fully polarised

POINTS TO WATCH

● *The sky is weak. Even a mild grey graduated filter would have affected the tops of the rock slacks and looked messy.*
● *No matter how many ultra-violet filters you put on the front of the lens, you can only cut down a certain amount of blue haze. It would certainly have grown worse during the day.*

METEORA, THESSALIA

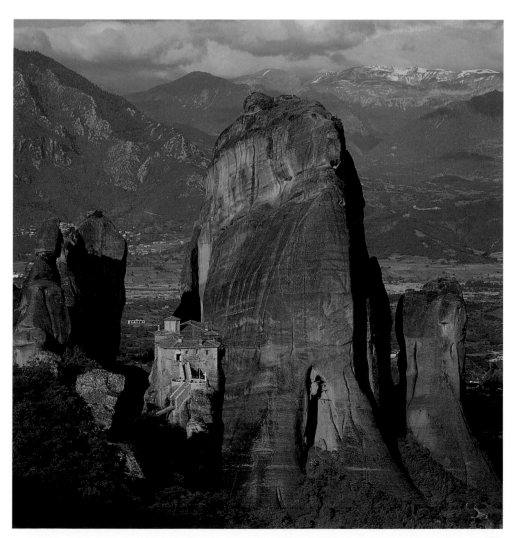

Where Light Confirms the Nature of the Place

EAST OF RONCAL, NAVARRA

This was very late in the day and the shadows were racing up the poplars. The sun was sitting on the top edge of the cliff behind. At first sight, I knew that these were the light conditions that could confirm the nature of the place. A massive wall of rock, steely blue and calm in the shadow, patterned with beautiful ox-bow curves where it had been shaped underground in ancient movements of the mountains.
And in front of that the glittering, backlit, visually mobile poplars. One can almost hear them rustling. It is a scene of opposites, perfectly folded in with each other, and which any other light conditions would certainly have diminished.

> Film: Fujichrome 50 ASA
> Camera: 6 x 6 centimetres
> Lens: Short telephoto
> Exposure: 1/4 second at f.22/f.32
> Filters: None

POINTS TO WATCH

● *It is important not to use a polarising filter if you want to keep the sparkle on the leaves.*
● *Try to get animals as neat as they are here, all pointing in the same direction.*
● *The short telephoto lens brings the picture tight in on its subject, but in doing so limits your room for manoeuvre. You have to make the picture on the spot, and not take a wider frame and later pull the picture you want out of it.*

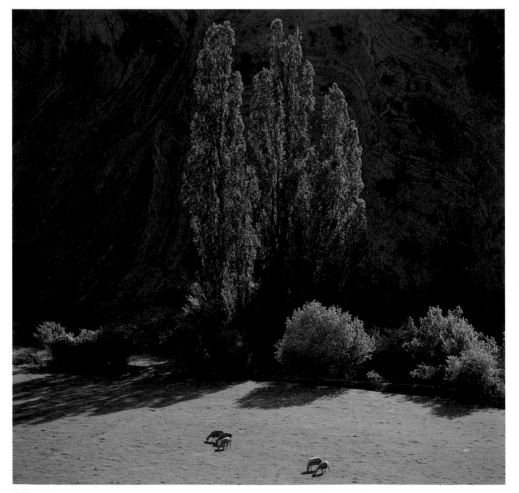

DURNESS, SUTHERLAND

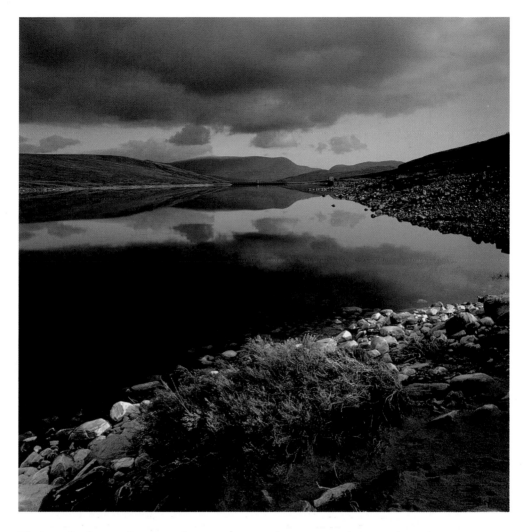

It is rarely clear at the time why a photograph seems to work, why the vision in the view-finder is a pleasing thing, but it is possible to analyse it afterwards. There are several elements at work in this photograph of a reservoir in Sutherland: the complete stillness of the water; the beautiful and sharply distinct colours of hill, heather, pebble and sky; the framing of the distant mountain by the reservoir banks. But none of this would mean as much as it does without the specific qualities of the evening light. This is almost the last moment of the lit day and I had waited here three hours for it.

Because I have framed the photograph so that the horizon comes almost three-quarters of the way up the picture, the part of the sky reflected in the water in the foreground is different from the part of the sky seen in the distance. It so happened, on this evening, that the sky was intensely black overhead and lighter, more grey, in the distance. The result, which doubles and enriches the presence of the sky in the photograph, establishes bands of light and dark in the picture. That is picked up in the foreground where a beam of late evening light is clipping the pebbles on the shore, so that their brightness is set against the blackest part of the reflected sky. The picture arranges itself through these successive layers of light and dark.

Film: Ektachrome 64 ASA
Camera: 6 x 6 centimetres
Lens: Wide-angle
Exposure: 1 second at f.22
Filter: Low density grey graduated

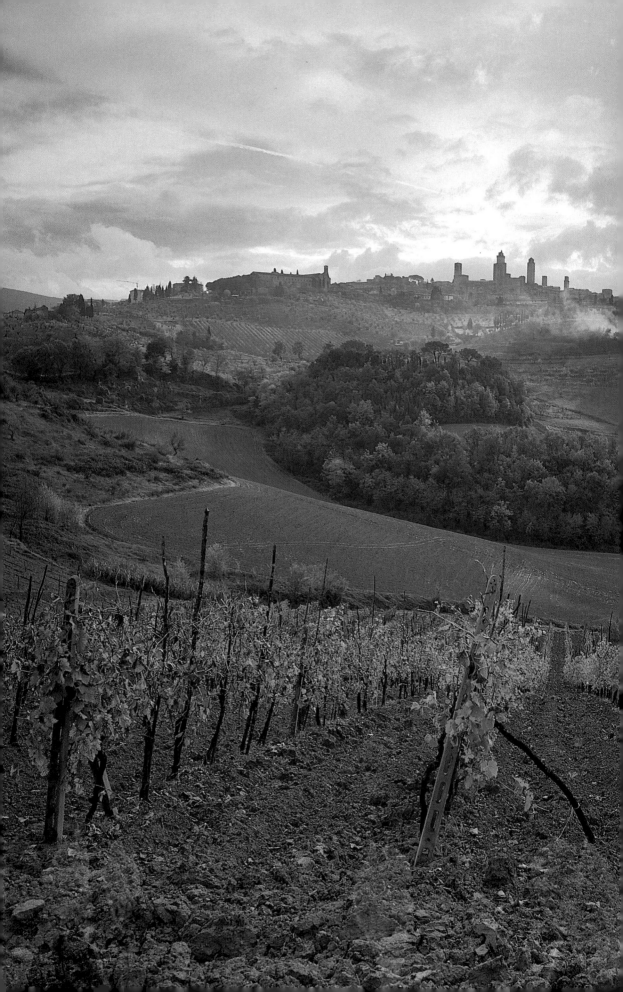

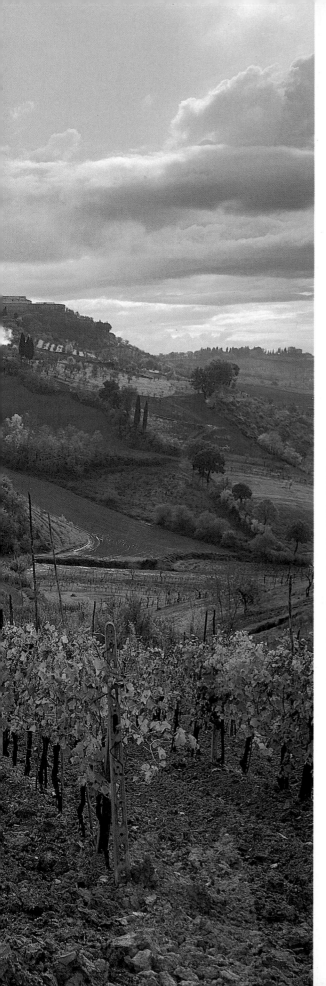

Calm

SAN GIMIGNANO, TUSCANY

If I was going to design an ideal landscape, this is the sort of place I would end up with. It is stable, structured, varied and complete. There is immediate order in the vineyard and an air of aesthetic coherence in the almost perfectly round coppice in the heart of the valley. Nothing conceals anything else. The land clearly belongs to the city and the city crowns the land, its visible head. This is surely a picture of the pastoral dream of what life might be like in the ideal state. But it is not embalmed. The smoke drifting from the bonfire is a crucially mobile element in the picture.

And for this dream of a possible reality, a place without anxiety, the light is calm, flat and diffuse, neither dramatic nor harsh.

> Film: Fujichrome 50 ASA
> Camera: 6 x 6 centimetres
> Lens: Standard
> Exposure: 1/4 second at f.22
> Filters: 81b warm-up

POINTS TO WATCH

● *I would have preferred the central vine to be in the very middle of the picture to get some sort of linear perfection, but there was a large red oil drum just out of the frame to the right which forced this slight asymmetry.*

● *The 81b warm-up filter has done a great deal to bring out the yellow that would otherwise merely lurk within the vine leaves.*

Magnificence

ST CLAUDE VALFIN, JURA

Only very rarely does a photograph continue to give me as much pleasure as this one. I feel nothing but gratitude for finding this place on the day and at the time of year that I did. Some rules had to go by the board – the bases of many of the trees have been cut off, but there is no problem with that because the rest of the photograph sweeps you up with the completeness of it. Sky and land are in unison, both in tone and shape. The pattern of scattered yellow larches diminishes towards a distance that holds a small bowl of mist in the valley.

But I think there is something at work in this picture which is not immediately apparent and may be the reason why I continue to like it so much. It is, in a way, a sleight of hand. The brightness of the yellow trees leads one to think that they are brightly lit. Usually that sort of intensity of colour only comes from something on which the sun is shining directly, or even when they are backlit and you are actually seeing the light of the sun through them.

But those are not the light conditions here at all. The light is actually as flat and diffused as in the photograph of San Gimignano on the previous page. So the effect, in one photograph, is full of two contradictory things: calm and excitement, flat light and sharp light, drama and ease. This, I think, must be the source of the pleasure this picture gives me, and perhaps it is a rule than could be generalised. If you have magnificent colour in a landscape, try to photograph it in as flat a light as you can.

Film: Ektachrome 64 ASA
Camera: 6 x 6 centimetres
Lens: Wide-angle
Exposure: 1/2 second at f.22
Filters: 81b warm-up, low density grey graduated

POINTS TO WATCH

● *Without the 81b warm-up filter the sky would have been greyish. It needs some warmth to relate it to what is going on down below.*
● *The graduated filter brings out the mottling in the cloud, to give it a sense of structure.*

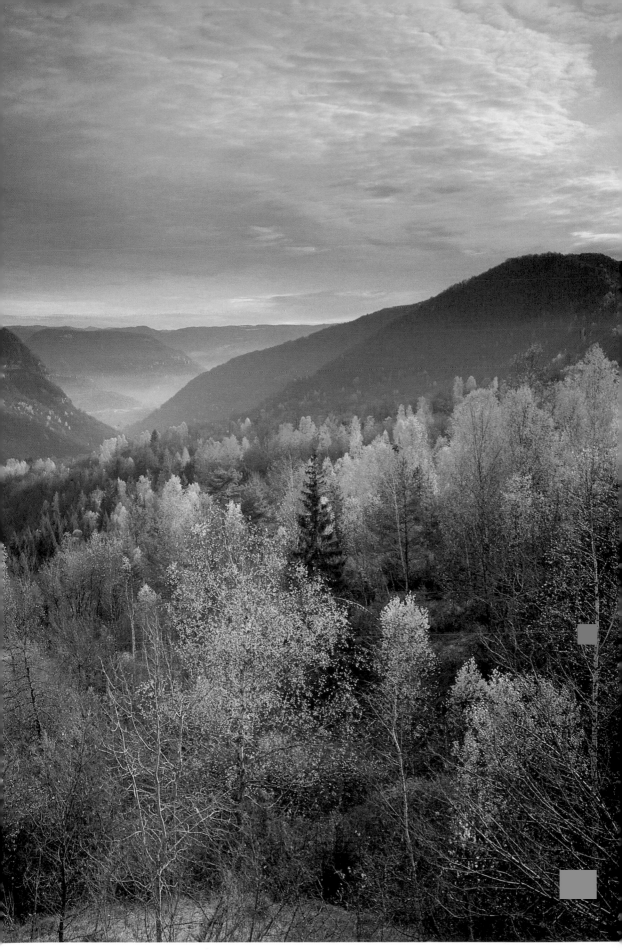

Choosing the Moment

EAST OF ILLORA, ANDALUCIA

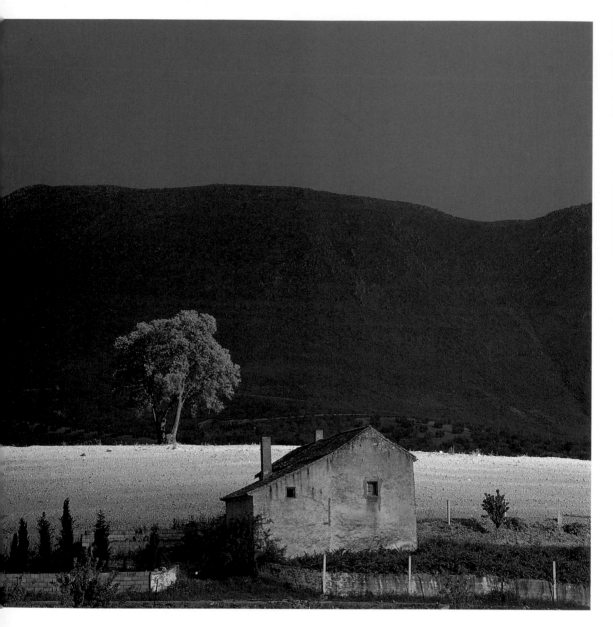

As a band of sunlight moves across a scene, you have before you the choice of where to place it in the landscape. These two photographs were taken a few moments apart. In the picture above, the face of the house is too similar to the tone of the earth behind it. There is not enough contrast between them and so definition is lost and drama reduced.

You might imagine that it is light which carries information but that is not strictly

Film: Fujichrome 50 ASA
Camera: 6 x 6 centimetres
Lens: Telephoto
Exposure: 2 seconds at f.45
Filters: None

true. It is the distinction between light and dark that conveys meaning, and here that distinction is not clear enough. On those grounds it is quite clear that the picture on the opposite page works better.

EAST OF ILLORA, ANDALUCIA

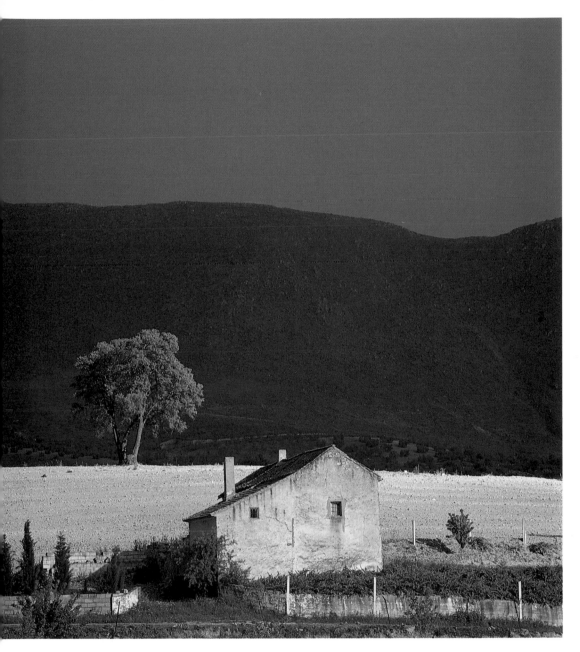

But that is not the end of the story. Try blocking out the sky with your hand on the picture above. The large bright patch of the sky is removed and a chance is given to the house. Now try removing the sky from the picture on the opposite page. For some reason, that picture then dies on you. Why? It is to do with the way in which the placing of light distributes weight around a picture and the sense of balance which the eye intuitively demands. But this experiment

Film: Fujichrome 50 ASA
Camera: 6 x 6 centimetres
Lens: Telephoto
Exposure: 2 seconds at f.45
Filters: None

does make one thing clear. Always take more than one frame when you have shifting and dramatic light conditions, simply to cover opportunities which you might not have recognised at the time.

Colour in its Place

Colour, in all its forms, is one of the greatest pleasures of photography, from blaring garishness to the suppressed, near-monochrome of a winter landscape. The chapter discusses the many uses of colour: the creation of a visual concordance, the isolation of a single colour element and allowing a landscape a full and varied palette.

IF YOU DO FIND a colour that screams at you, make an issue of it. One of the drawbacks of colour photography is that things can be too colourful. But sometimes the only option is to make the lurid even more lurid, to abandon good taste and allow what is, after all, there to shout at you.

But with such loud colour there is one overriding rule: do not make the structure too fussy. These pictures work by denying subtlety, slamming on the colour and amazing by their sheer chromatic presence. There is nothing to read between the lines because nothing is concealed. It is this almost nursery-style simplicity of colour, coming in large, identifiable blocks, that, for this sort of picture, you must look for. A straight-forward idea: loud must be simple.

It is worth asking whether this picture would have worked without the shed and trees. Perhaps it would but at a slightly lower level. I don't think I was aware of it at the time, but everything in the picture I have arranged as tightly as possible. Those structural elements are the means by which the photograph is screwed down tight. The two trees are exactly symmetrical about the shed. And the shed is bang in the middle of the frame. This has meant that I have not been able to look straight along the lines of the lavender, but that is unimportant. It is worth noticing just how hideous a building this asbestos-roofed, breeze-block shed is. Another simple lesson: very strong colour can override what might have been the drawbacks in the photograph.

NEAR VAISON-LA-ROMAINE, PROVENCE

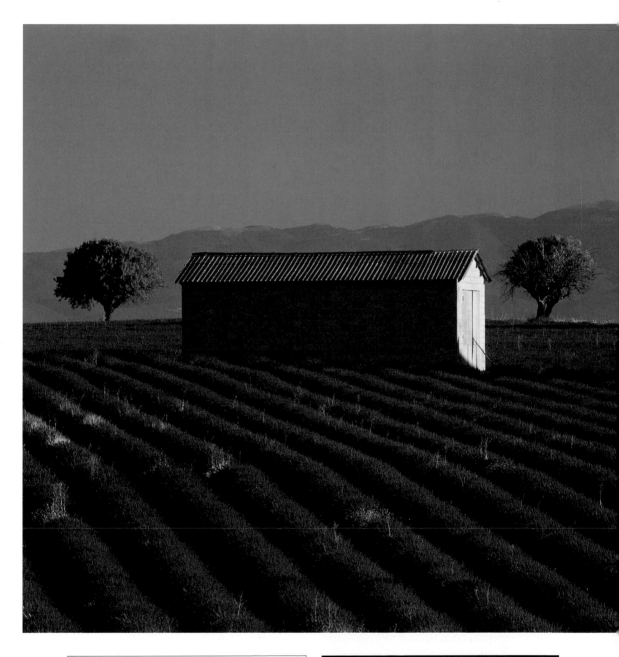

Film: Fujichrome 50 ASA
Camera: 6 x 6 centimetres
Lens: Short telephoto
Exposure: 1/4 second at f.22/f.32
Filter: Polarising, fully polarised

POINTS TO WATCH

● *The polarising filter by cutting out reflected light saturates the film with colour. This adds enormously to the uncompromising effect needed here. Reflections would have lessened the colour density and you would have started to pay more attention to the (fairly unattractive) appearance of the shed.*

● *Notice how the highlight at the the end of the shed shapes the picture. Use your finger to block it out and see how much the photograph loses.*

The Complementary and the Different

NORTH OF MONTEVARCHI, TUSCANY

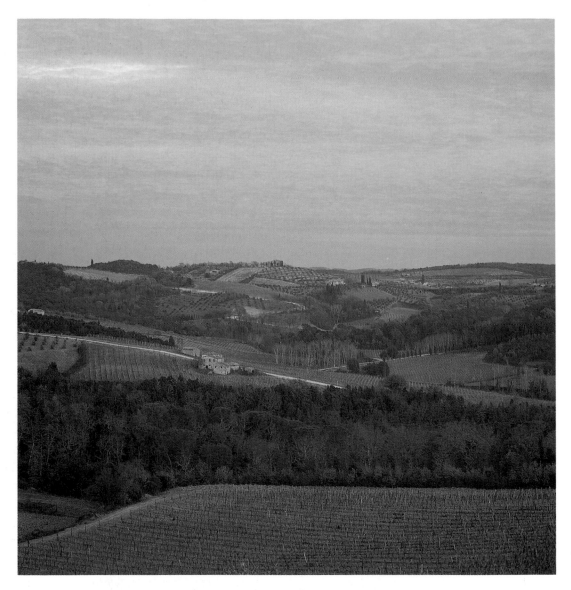

This winter landscape is fast asleep, hibernating. The sun had set at least half an hour before this picture was taken. The sky alone is lit by the sun. There is no direct light on the land, and so the two elements of the landscape are seen in different conditions. There is something unsettling about that. No one would ever have chosen this combination of colours for their clothes. Some kind of silky grey would have been the sky colour that fitted. But this is a picture that works by bringing two uncomplementary things up against each other.

Film: Fujichrome 50 ASA
Camera: 6 x 6 centimetres
Lens: Short telephoto
Exposure: 2 seconds at f.32
Filters: None

POINT TO WATCH

● *Do always – and this is something one can only repeat – check around the edges of the frame of the photograph. Nothing extraneous should be there. Here, in an ideal world, the olive branches at the bottom and at the bottom right would have been excluded.*

This is the other side of the coin. Here everything is soaked in the same liquid colour of the evening: orange leaves, tiles, light. The mild warm-up filter I used did little to enhance the natural and astonishing terracotta of the air, the last light scattered by the dust at the end of a hot day. It is like a musical chord in which each of the surfaces in the landscape – the ochreish patina on the walls, the lichened ochre of the tiles – makes its own separate but concordant note. If you want this effect, look for the place whose own natural colours match the colour of the light you expect to find.

BONNIEUX, NEAR APT, VAUCLUSE

Film: Fujichrome 50 ASA
Camera: 6 x 6 centimetres
Lens: Short telephoto
Exposure: 2 seconds at f.32
Filter: 81b warm-up

POINTS TO WATCH

● *The very low light has meant a long two-second expoure. Anything with any movement in it will blur in that length of time, but for this sort of picture, that does not matter enormously. The point here is mood and suggestiveness, not precision.*
● *Use a warm-up filter to enhance natural light.*

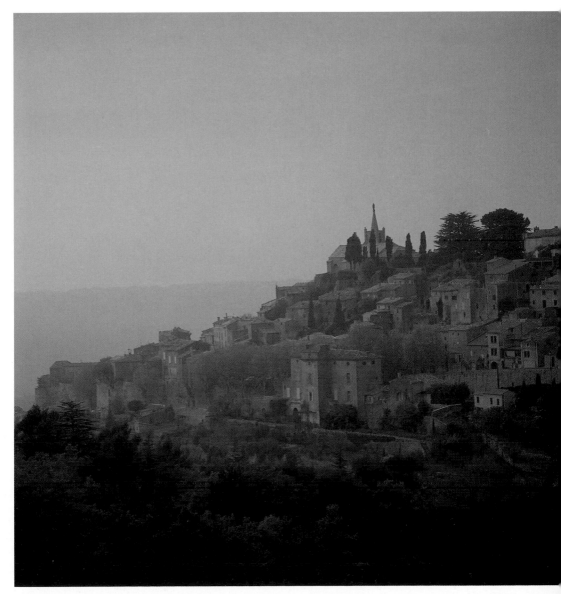

A Moment of Colour

SOUTH OF OYARZUN, GUIPUZCOA, CANTABRIA

Here is something quite familiar from another context but enacted in a different way: the single statement, not here in terms of form but purely in terms of colour. You must be very careful if you are going to try this: the shape of the colour block itself is crucial – it must be a beautiful thing; the colour relationships between the central revealed object and the colours and shapes surrounding it are equally important.

I am pleased with this picture, with the mouth shape and the beautiful milky green of the dew-soaked grass of the field, the placing of the haystacks, the russet of the surrounding hills. It is like a slash in a cloth, a revelation of the colour of the flesh underneath.

> Film: Fujichrome 50 ASA
> Camera: 6 x 6 centimetres
> Lens: Telephoto
> Exposure: 2 seconds at f.45
> Filter: Polarising

POINTS TO WATCH

● *Don't let the excitement of the main focus of the picture allow you to forget the outer edges, which if uncontrolled distract from the central idea. Another splash of green, for example, would have totally undermined the picture.*
● *On this overcast day there are no highlights. But that is fine; the colour itself, rather than the patterning of light and shade, organises the structure of the picture.*

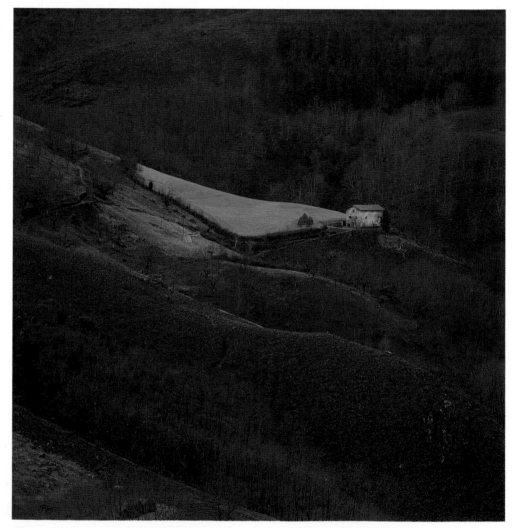

I was looking due west as the sun sank under the horizon. Anything photographed into a bright light will appear in silhouette, but the two silhouettes here have taken on quite different and beautifully concordant colours. The mauve of the mountains is perhaps influenced by the the mist rising from the swamp that lay between them and me. The trees are in fact utterly black but a strange trick of the eye makes them appear orange. But the point is this: the control of structure in a fully coloured photograph is quite crucial. If the colour is this dramatic, keep the form strict and simple.

Film: Fujichrome 50 ASA
Camera: 6 x 6 centimetres
Lens: Wide-angle
Exposure: 1 second at f.22
Filter: 81b warm-up

POINT TO WATCH

● *Fractional movement in the water over the long one-second exposure necessary in these light conditions hazes the reflection of the trees slightly. This is both unavoidable and beautiful in itself. It is another example of that familiar recipe: the repetition of something, but with a slight difference.*

NEAR SELESTAT, SOUTH OF STRASBOURG, BAS-RHIN

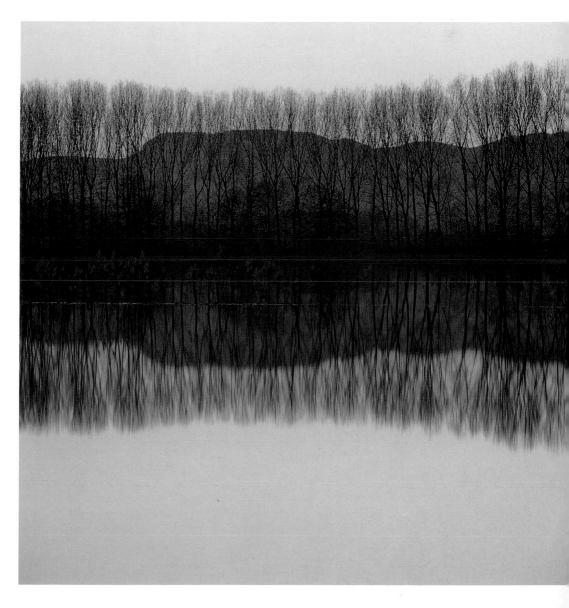

Black and White Colour

CHARLESTOWN, CORNWALL

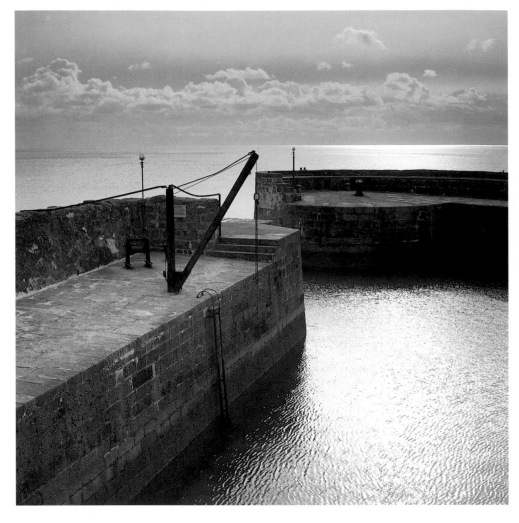

What is it that is so pleasing about an almost colourless colour photograph? I think it might be, at least in part, the sight of something operating so utterly within its capabilities. Here is modern colour film, able to reproduce so much that is so ferociously chromatic, being used to reproduce the nearly monochrome. It is similar to the phenomenon of a Rolls Royce cruising downhill at no more than ten miles an hour.

But there is also something more: the pleasure of the simple rarity. A scene as drained of colour as this is as uncommon in the natural landscape as something which is as bright with colour as the lavender field on page 95.

Film: Ektachrome 64 ASA
Camera: 6 x 6 centimetres
Lens: Wide-angle
Exposure: 1/8 second at f.22
Filter: High density grey graduated

POINTS TO WATCH

● *This is a very heavily backlit scene . The sky was very bright; to bring it within the tonal range which the film could deal with, I had to use a heavy grey graduated filter. The detail in the cloud here was not visible to the naked eye.*

● *You can always use a graduated filter at the coast. The absolute flatness of a sea horizon means there is no danger of the dark part of the filter invading parts of the picture, such as a hill or a tree, where it would have been unwelcome.*

I love these khaki grey beiges. It is as if someone has a put a single drop of colour into a glass of water and then washed the whole landscape with the mixture, the subtlest and slightest of colour gestures. Even in the warming light of late afternoon, even with the polarising filter on to squeeze out what colour was there, this remains a mute, understated, cool denial of everything you might expect to find in an Italian landscape. And that, I think, is the key. Removing colour allows you to stand outside the over-colourful, postcard way of seeing things. It is a way of saying 'Look: this is something that was there but which you did not bother to see.'

WEST OF SINALUNGA, TUSCANY

Film: Fujichrome 50 ASA
Camera: 6 x 6 centimetres
Lens: Standard
Exposure: 1 second at f.22
Filters: Polarising, half polarised,
low density grey graduated

POINTS TO WATCH

● *Winter is the time for delineated shapes and reduced colour. The greenery of summer is a thickening thing which tends to obliterate form. Where summer is fleshy, winter is bony. It is often the time when you can get a new look at the over-familiar.*

● *Use a polarising filter to squeeze the last remaining drops of colour from the day.*

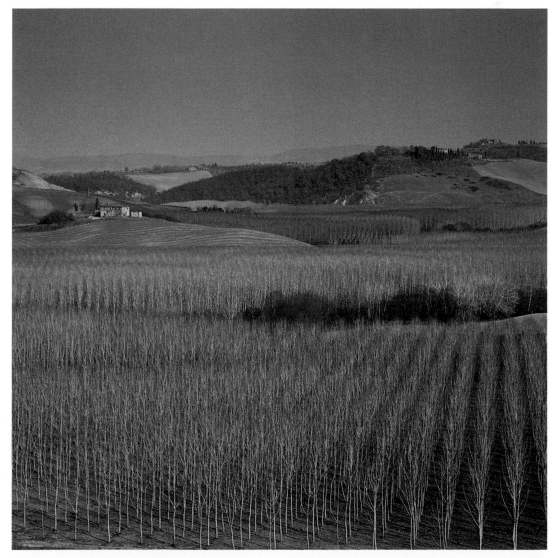

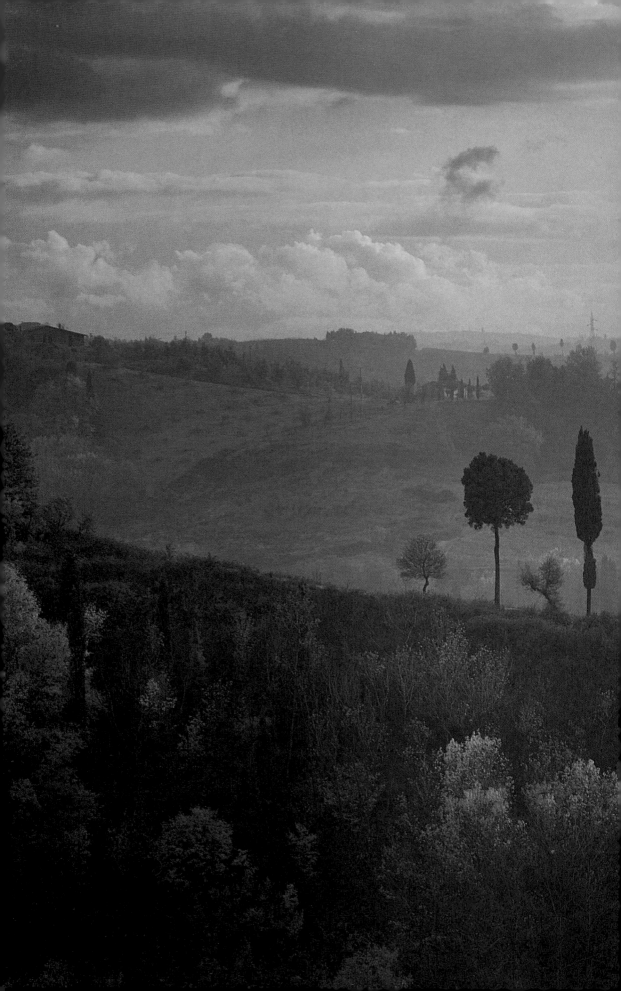

Something Over Which the Eye Can Roam

SAN MINIATO, SOUTH OF FLORENCE, TUSCANY

In the end, there is something about distortions of colour in the landscape – either exaggerating it, or over-selecting it or almost removing it – which does not treat the landscape with the respect and subtlety it deserves. And there is something else about a photograph like this one in Tuscany which in its suggestive, detailed, easy, undemonstrative, accommodating beauty goes beyond those more obvious manipulations. Here is something over which the eye can roam – delicately orchestrated by the slight formal gesture made by the two trees, but going beyond that to a composition of colour and form which embraces an entire constellation of feelings and memories of Italy, something for which no formula, no tried and trusted way of doing things, can really prepare you.

Film: Fujichrome 50 ASA
Camera: 6 x 6 centimetres
Lens: Short telephoto
Exposure: 1 second at f.32
Filters: None

POINT TO WATCH

● *Consider for as long as you can before deciding what picture to take in a place. Stay with it so that the photograph might include the less obvious meanings to be found there. Here the two trees were the first thing that caught my eye, but I realised after a while that they were only part of something bigger, better, richer, softer and more long-lasting. Familiarity can often breed content.*

Sky and the Landscape

The sky is the most mobile element within any landscape and the source of a great deal of its drama. This chapter shows how to make the sky fit in with the landscape below it and, both in the daytime and in the dramatics of a sunset, how to use it to establish an element in the picture which the landscape itself cannot provide.

WHEN THESE ROUND straw bales first began to appear in English fields – it was in the late 1970s – I immediately took to them, for their lovely big shapes, their big sculptural gestures in the landscape. On the face of it, they look easy enough to make a picture of, but it is harder than you would think. Getting them in position, getting them into a pattern that satisfies, I have often found infuriatingly difficult. But this picture was different. I saw the bales of straw and, at almost the same time, in the distance, the rolls of cumulus approaching from the west. It was extraordinary – a bank of cloud rolling towards what seemed like its (photographic) destiny. I simply waited and clicked as the moment happened, and the patterns coincided.

This was obviously an extraordinary and rare occasion when the shapes of the clouds exactly and precisely matched the shapes on the landscape below them. That sort of thing does not happen every day. But the principle, if in a more muted form, remains the same: that you should establish a relationship between sky and earth.

The heart of a good sky in a photograph, I think, consists in your conceiving what is front of you not in terms of two elements which have to be brought into relationship with each other, but as a pair. One part is in motion and the other is still but reflects the changes going on overhead. Think of sky and earth as an indissoluble coupling and you will not go far wrong.

104

NEAR STONEHENGE, WILTSHIRE

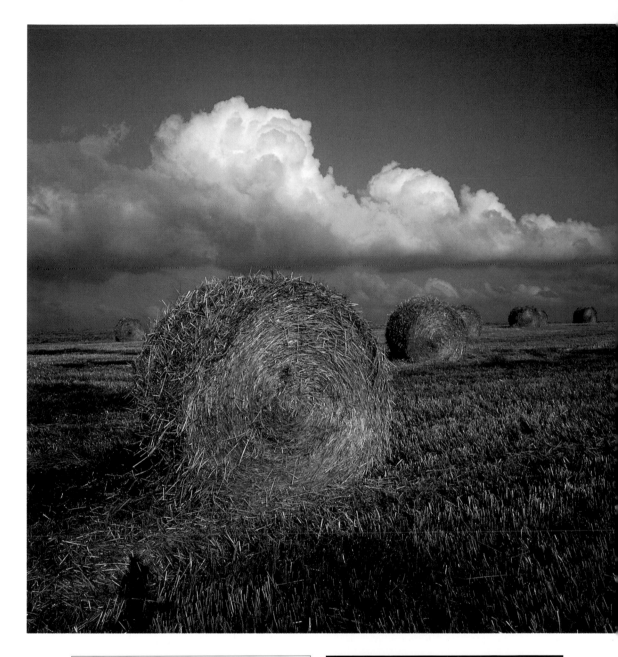

Film: Ektachrome 64 ASA
Camera: 6 x 6 centimetres
Lens: Wide-angle
Exposure: 1/2 second at f.22
Filters: Polarising

POINTS TO WATCH

● *If symmetry suggests itself in sky and landscape, do your best to make use of it.*
● *Make sure that the gaps between repeated single objects such as these bales remain clear.*
● *Here the sun was directly behind me. In this situation you should be careful that neither your own shadow nor the shadow of the camera on the tripod appears in the photograph. Here, I am afraid, the camera shadow has crept in. A pity, but not, I hope, noticeable unless pointed out.*

The Sympathetic Sky

MONT SAINTE VICTOIRE, BOUCHES-DU-RHONE

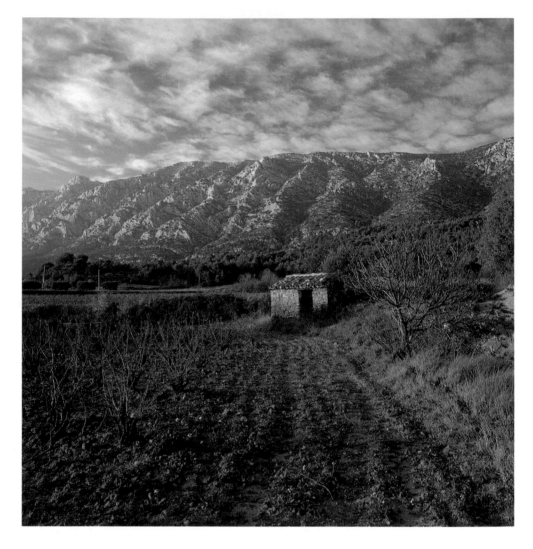

If you half shut your eyes and look at this picture of Mont Sainte Victoire, what do you see?

A single textured, bobbled cloth in three rough, almost woollen stripes, the colour of the red earth, of the mountain and of the sky? I hope so because of all the pictures I have taken, this is the one that most conveys that magical *continuousness* of tone between sky and earth and everything that grows on it. This is something that can often be felt when you are in a beautiful place but which a photograph can only rarely convey. It is a point where for once the sky is sympathetic to the flecky, speckled, flickering surface of the earth.

Film: Ektachrome 64 ASA
Camera: 6 x 6 centimetres
Lens: Wide-angle
Exposure: 1/2 second at f.22
Filters: Polarising

POINTS TO WATCH

● *Don't allow one element to dominate. To preserve the coherence of a picture like this all parts must be in balance. A heavy graduated filter would have overcooked the sky.*
● *This picture would not have worked without the low light revealing the grittiness of the soil or creating the shadow in the mountains. When I passed this place again, several years later, and the light was different, I hardly recognised it.*

The long exposure on the water has silkened it, bringing it up to the texture of the sky, so that the water looks to me like beaten copper, the hammer marks still on it. A shorter exposure would have toughened up that surface, giving far more defined edges to the reflections. But that would have been wrong, disrupting the concurrence that is now there in the picture. But it is colour as well as texture that comes together here – in the water and in the roofs and walls of the town. The sky was in fact grey and I have brought it into line with the other colours of the picture by using a graduated filter. So this, in the end, via filters and long exposures, is something of a manipulated image, achieving artificially an effect something like what was there naturally at Mont Sainte Victoire.

Film: Ektachrome 64 ASA
Camera: 6 x 6 centimetres
Lens: Wide-angle
Exposure: 1 second at f.22
Filters: Low density grey graduated

POINT TO WATCH

● *When photographing sun reflected in water, watch out for unwanted and disruptive flare in the lens. With water, there are always two suns to look out for.*

CANDES SAINT MARTIN, LOIRE

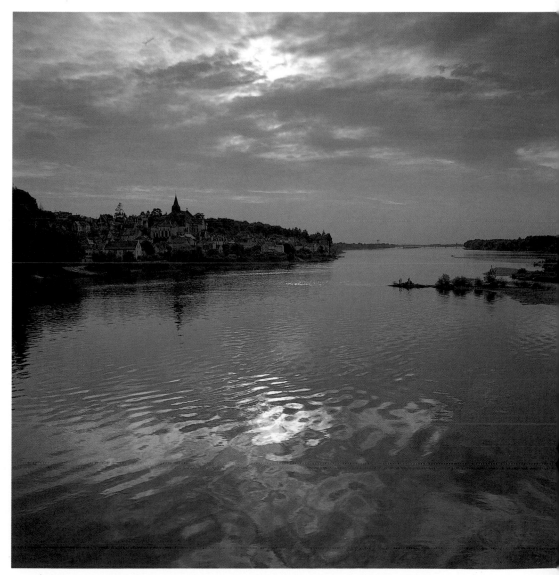

The Sheltering Sky

THE MANGER, UFFINGTON, BERKSHIRE

The soft and female shapes and colours of the chalk landscape of southern England reach their most perfect form in this combe near Uffington in Berkshire. The land is fleshy and animal in shape and feel, a huge body laid out on a sofa, rolls of flesh, or the eight fat fingers of a millionaire's hand clustered around the stub of a cigar. And in this, the black sky plays an all-important role: it *disciplines* the picture, holding it in, so that the viewer's attention doesn't wander off into the uninteresting distance. The natural light makes the drama clear: lit flesh against a dark background.

Film: Ektachrome 64 ASA
Camera: 6 x 6 centimetres
Lens: Wide-angle
Exposure: 1/4 second at f.22
Filters: Medium density grey graduated

POINTS TO WATCH

● *The razor edge of light along the ridge on the left hand side is important to the shapeliness of the photograph – to the revelation of shape within the picture. Block it out or imagine it away and see how the picture is diminished.*
● *A high viewpoint like this – level with the clouds – almost always adds to a picture. It helps to box in what is interesting in the landscape.*

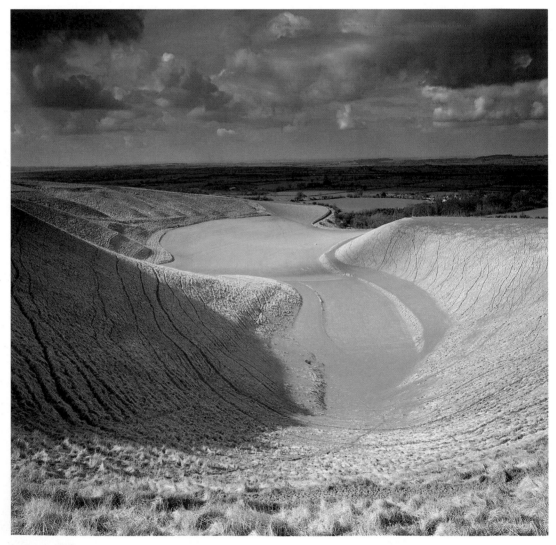

This place could have made a very good photograph. These strange tree stumps, half-drowned, immediately struck me as very odd looking things, creatures from space or giant fossilised starfish. But this was an utterly wasted opportunity. It could have been so much better than what I ended up with here. The sky is the mess. It is too obviously artificial and has no real identity or character. That blue splurge at the top of the frame comes simply from a massive overuse of the polarising filter. One simple lesson emerges. You can enhance but you cannot add. I have tried here to give the sky a depth and resonance that was never there and the picture should not have been taken.

Film: Ektachrome 64 ASA
Camera: 6 x 6 centimetres
Lens: Wide-angle
Exposure: 1/4 second at f.22
Filters: Polarising

POINT TO WATCH

● *Don't think a polarising filter will make a picture whatever the conditions.*

ALEMOOR LOCH, HAWICK, BORDERS

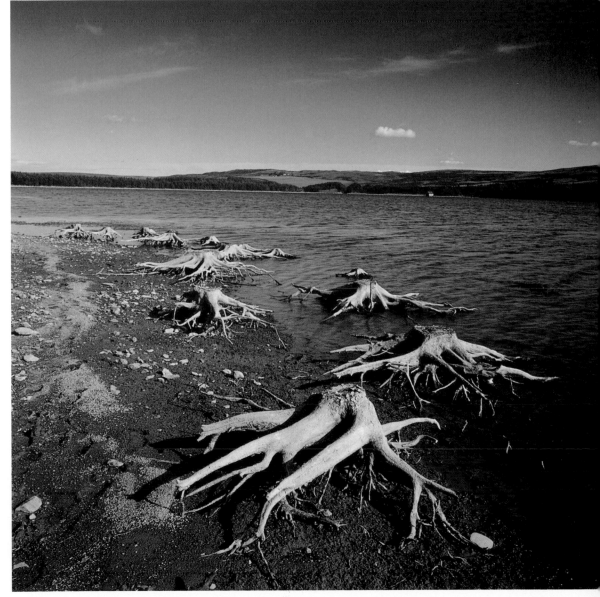

The Sky's Great Finale

NAFPLION, PELOPONNESE

I almost never photograph a sunset. But there is no need to be frightened of the beauty in something which everybody considers beautiful. Searching for the unusual or the hidden beauty is all right if it stops short of becoming a rule or a fetish. Why not take a sunset for what it can give you now and then? It is, of course, not good enough simply to pick up the camera and point it at a red sky. You must first wait until almost the very last moment, when the sun has nearly gone. Otherwise you will get flare in the lens. Even then you must use a graduated filter to darken the sun – it is always much brighter than you think – and to bring the brightness range within the limits that the film can deal with. In this case it was important to have detail both in sky and sea. Without the graduated filter and at this length of exposure, the sky would have appeared totally burnt out. If I had exposed for the sky without the filter (which would have been a much shorter exposure) the sea would have appeared almost completely black and without detail.

Film: Fujichrome 50 ASA
Camera: 6 x 6 centimetres
Lens: Wide-angle
Exposure: 1 second at f.22
Filters: 81c warm-up, medium
density grey graduated

POINT TO WATCH

● *A sunset is the sky's great finale to the day. This is the moment when the sky takes centre stage and to give it what it deserves, you must lower the horizon as I have done here. This is especially true over broken water, where the sky is rich with information but the water contains very little indeed.*

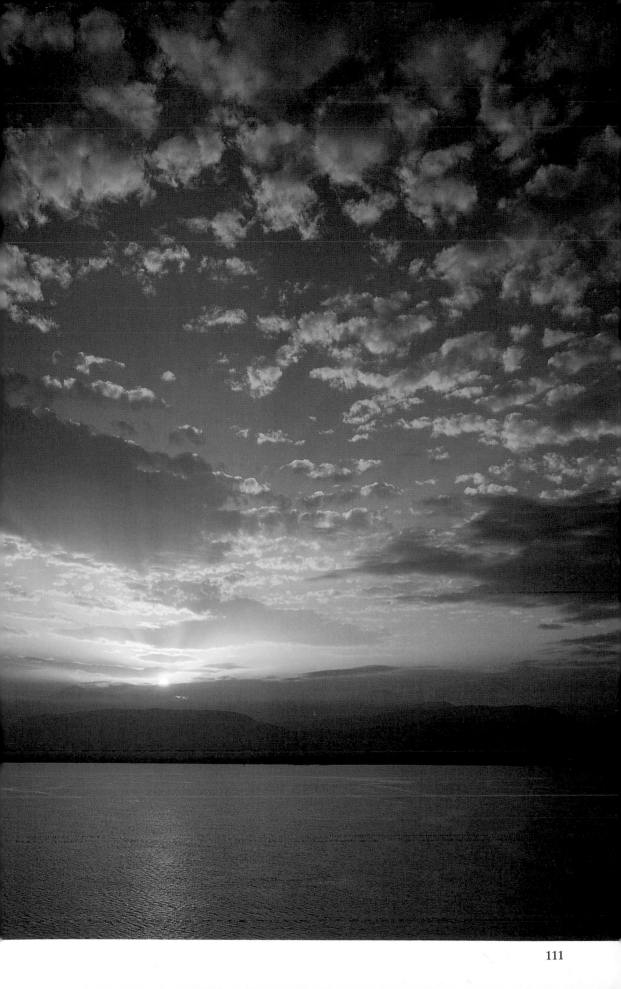

Water and the Landscape

Water is the most magical and alluring of all elements in the landscape, particularly for the many and varied ways it relates to light in a landscape. Look for the differences between still and moving water, for its combinations of reflective and translucent qualities and the different ways that water can convey a mood.

The trees in this picture take up only about 1/40th of the picture space. Nevertheless they manage to dominate the scene. Why? Partly, I think, because they are are placed so squarely in the middle of the frame, commanding the scene like an actor performing a soliloquy. But the reflecting water plays a key part too, as if, to continue the analogy, it were the audience, reflecting the importance of what is happening on stage.

I am sad that the reflection of the trees is interrupted by the grass of the field emerging through the flood. But there was no way around that problem and in this case something was better than nothing. I do at least like the way that the tops of the trees are held within the boundaries of the water, and I can console myself by saying that you don't always have to look for perfection to get something that, in its own terms, works.

Your ears should prick up when you find water in the place where you are out to take some photographs. Because water is one of the great allies of the photographer for the simple reason that it is so protean an element. As a still reflecting pool it can do everything the sky can do, but water goes on well beyond that: it can bend and colour light, it can enact its own drama in a wild sea, it can take on the astonishing appearance of molten metal, it can in a waterfall actually portray the passing of time in a stilled image – and so on. Always be alert to its moods and possibilities. It will always reward you.

RIVER THAMES AT WALLINGFORD, OXFORDSHIRE

Film: Ektachrome 64 ASA
Camera: 6 x 6 centimetres
Lens: Standard
Exposure: 1 second at f.22
Filters: None

POINTS TO WATCH

● *There is too much heavy black in the foreground. This picture would be better cropped above the fence. Try it with your hand and you will see how the main purpose of the photograph becomes much clearer.*

● *The ruffling of the water just where the reflections of the trees meet it is a little unsettling. Ideally that reflecting area should be quite still. Always wait for a lull in the breeze if you can.*

Water as Something Beautiful in Itself

RIVER CUCKMERE, SUSSEX

MOUSTIERS ST MAIRE, PROVENCE

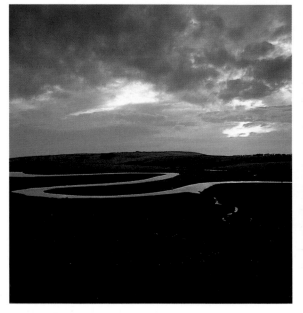

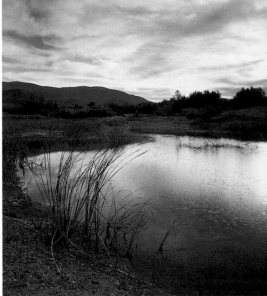

Few sights are more beautiful than the still and reflecting light of a slow-moving river at dusk. The meanders of the Cuckmere in Sussex, rolling out to sea through a soft, round-edged valley in the Downs, provides a perfect image of ease and calm. The water is unruffled. The relative turbulence of the sky serves to heighten the smooth and balanced surface of the water. It would have been lovely if the river had picked up more light from the sky, but the one highlight on the right hand side does at least provide the low-key climax to an understated photograph: a gilded moment in a picture of shadows.

Here the water's reflection of the sky is better than the sky itself. The calm is absolute. It is an entirely unified picture in which everything is understood simply in different tones of pink.

This is water not as a reflective element but as a continuation of the landscape by other means. Here it is soft and inviting, the water becoming the most alluring of all places, a surface capable of the sort of miracles which grass and soil could never hope to match.

Film: Ektachrome 64 ASA
Camera: 6 x 6 centimetres
Lens: Wide-angle
Exposure: 1 second at f.22
Filters: Low density grey graduated

Film: Fujichrome 50 ASA
Camera: 6 x 6 centimetres
Lens: Wide-angle
Exposure: 1 second at f.22
Filters: 81c warm-up

POINTS TO WATCH

● *In a picture of calm one uncalm element can enhance rather than diminish the effect.*
● *Don't go home before the last drop of light has been squeezed from the sky. It is often at those marginal moments that something beautiful emerges from an everyday scene.*

POINTS TO WATCH

● *For this kind of effect an absolutely windless evening is vital. Everything must be sharp – no sentimentalised fuzziness here – and for everything to be sharp, the depth of field must be at its maximum. The aperture you use must therefore be small.*
● *With a small aperture you need a long exposure. Only a windless evening will give you an unblurred reed.*

The only time water is going to look truly wet and liquid is when it is backlit like this, seen as a bubbling, spilling surface, the eddied mass of a supremely mobile element caught at a literally unrepeatable moment. No picture of this could ever look exactly the same. This is one of the miraculous forms of water, a foundry swimming with molten metal, or at least a place in which the two elements of light and water are somehow fused. It is the opposite of the picture on the following page: not a single drop of light penetrates below this boiling surface.

Film: Fujichrome 50 ASA
Camera: 6 x 6 centimetres
Lens: Wide-angle
Exposure: 1/60 second at f.8
Filters: High density grey graduated

POINTS TO WATCH

● *To catch water fixed at a particular moment you must use quite a fast exposure, but to get a full depth of field the aperture must remain quite small. It is therefore necessary to have quite a fast film (at the expense of some graininess in the image) or restrict yourself to times of the the day when there is quite a lot of light.*

RIVER DORDOGNE, ARGENTAT, CORREZE

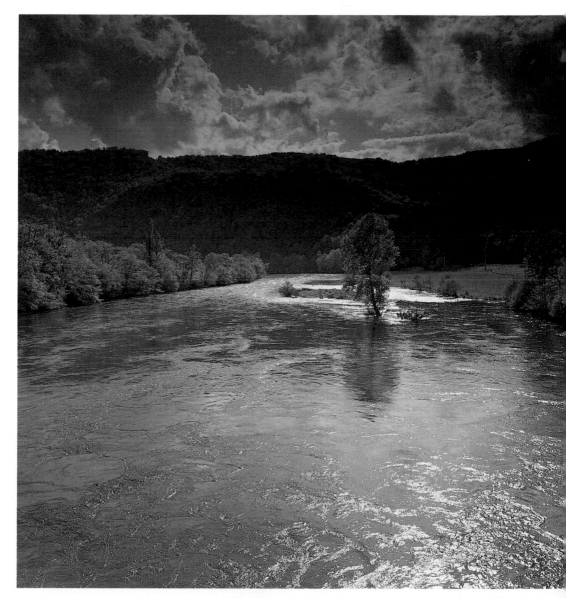

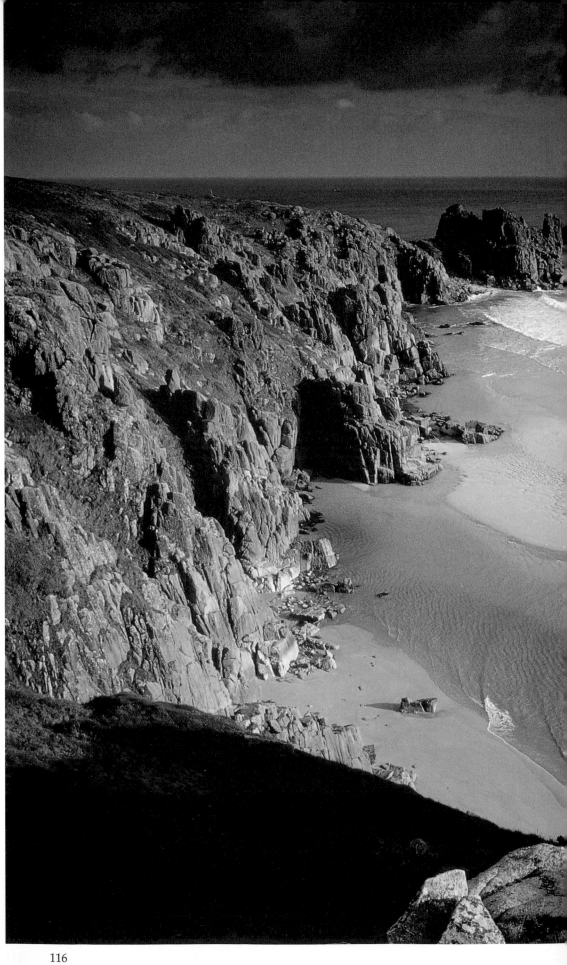

Aquamarine

CLIFFS AT TREEN, CORNWALL

Here is water not as a reflector, nor as a continuation of the landscape by other means, but as a transparent medium. Of course, for water to be transparent to the light you must be relatively high above it, as I was here on the cliff top. And this was a wonderful evening. The white light that always comes creeping around the sides of a dark sky is reflected here off the pale underwater sand in a Cornish cove. The result is an extraordinary liquid green, water with the internal lights of a jewel. The slight ruffling from a breeze off the channel, the brilliant white of the surf, the theatrical low sidelighting in the last moment before sunset: if you think that these might be the conditions you will find, have no hesitation: drive straight to the nearest cliff, and if you are lucky you will find something like this, half-fjord, half-Bahama, water lit from within.

Film: Ektachrome 64 ASA
Camera: 6 x 6 centimetres
Lens: Wide-angle
Exposure: 1/8 second at f.16/f.22
Filters: Polarising, low density grey graduated

POINT TO WATCH

● *One apparently incidental element in the picture, the white rock in the foreground, is oddly enough the key to it. Block it out with your hand and the dark mass in the foreground kills the rest of the picture stone dead.*

Catching the Exact Moment

MARINA DI ALBARESE, TUSCANY

The sea was sweeping back and forth around this log on a beach near Pisa. The picture is pleasing because of the moment it was taken, the precise visual arrangement of parts within a highly mobile landscape. It would not have been successful if the sea had been up to the foreground because the smooth stability of the wood, planed down over many years by the workings of the sea, would not have been so pronounced and the sense of natural sculpture would have been lost. A large, frothy white surface in the foreground would have dominated the picture and the result would have been a mess. But at this moment, the waves have withdrawn from the beach, leaving it wet and reflective, and the log stands free of the water, a piece of giant flotsam on whose limbs the sunlight creates a rich amber warmth.

Film: Fujichrome 100 ASA
Camera: 6 x 6 centimetres
Lens: Wide-angle
Exposure: 1/60 second at f.11
Filters: Polarising, low density grey graduated

POINTS TO WATCH

● *The picture would have been better without the small bridge of sand lying between the two parts of the tree. I tried to dig it away, but the sea always brought the sand back in.*
● *In order to balance the relatively sombre tones of the beach, I have used a grey-graduated filter.*

Buildings and the Landscape

Buildings can give a sense of proportion to a landscape; but the relationship between the two must be handled very carefully. This chapter points out the problems and the opportunities: how to set the building in the landscape, giving it its due and respecting the architect's intentions while avoiding the problems of distortion.

THERE IS A GREAT freedom about buildings in isolation: you can do almost what you like with them. This, for many years, has been one of my favourites. Not particularly because of the formal properties of the photograph (although if you take the thresher away with your hand, you will see that the picture dies without it, without its repetition of the four-part nature of the shed and its angle to the camera). No, what I like about this shed is the way it is like an old piece of landscape which has been made and remade, displaying its own half-sorry history.

Nothing is more readable in the landscape than the face of a building, and nothing more able to mimic the presence of a human being in it. Perhaps it is a little fanciful, but I always like to see this shed as a rather battered old man who is still trying to do his best in the worst of times. It is the way in which every conceivable material has been put to use with a thought only as to what it might do in the circumstances that makes this such an endearing shed. Nothing has been tarted up here. It is, in other words, an honest building. It is not pretending to be anything other than what it is and in that there is a real delight. That straightforwardness, an explicitness about oneself, is the pleasure of the close-up portrait of the human face. And in the landscape the only things that can come up with the same mixture of vanity, pride, experience and impending, half-arrested decay are the buildings scattered on its surface.

LA LANDE POURRIE, MANCHE

Film: Ektachrome 64 ASA
Camera: 6 x 6 centimetres
Lens: Wide-angle
Exposure: 1/4 second at f.22
Filters: 81b warm-up, low density grey graduated

POINTS TO WATCH

● *The vapour trail in the sky is annoying. I should have waited for it to clear but the light was going.*
● *The shadow is too deep on the right-hand side. But again there was no real choice; I had to expose for the building.*
● *I got here after a long traipse across a muddy field. I didn't have a ladder with me, but that would have improved the picture. From a higher standpoint the tops of the trees on the right would have come below the horizon.*

Placing the Structure in the Frame

TROO, LOIRE

You have to have a good look around a building. I arrived at the south side of this church and thought, 'No, I won't bother.' But I know from experience that first thoughts are usually hopeless, second worse, and that only third, fourth or fifth ever have anything to say for them. So I walked around the church, to the east end, up a little hill, and using my thumbs and index fingers as a makeshift frame, saw that this picture was there. I was right up against the churchyard fence and if it had been even one foot nearer the building I could not have got the picture. Because one thing above all is true when photographing buildings: you must never point your camera *up* at them, because to point a camera up is to make all the verticals – walls, drainpipes and so on – apparently converge. A building if treated in this way starts to look like a pyramid.

There is another point to look for here. Treat a building as you would a person's face. Fill the frame with a building and you will reveal its character. Look carefully for the creases and wrinkles.

Film: Ektachrome 64 ASA
Camera: 6 x 6 centimetres
Lens: Wide-angle
Exposure: 1/4 second at f.22
Filter: Polarising

POINTS TO WATCH

● *Make sure that the bright patches on the walls retain the details of the stonework. Don't overexpose. Nothing looks worse than burnt-out, overbrightened areas.*
● *Pale stone buildings reflect their own light so the shadows will be of no great depth and will always be a little lighter than they look to the eye.*

LAVARDIN, NEAR VENDOME, LOIR-ET-CHER

Anything seen from below, looking up, takes on an air of importance. It dominates the picture rather than taking its place within it. The wall on the right and the shed on the left both frame the central tower and this too adds to its air of dominance. Conventionally, it is not considered right to put the main focus of interest in the middle. But here – as so often, in fact – it works, partly perhaps because the nicely designed baker's board at least half-draws one's attention to the side. In this way balance in pictures of buildings can be subtly achieved. And to make the balance subtle is often far more satisfactory than a more obvious symmetry which, because it can look so contrived, can remove the sense of reality from the picture. It all depends on what you are looking for: a sense of the real or a sense of something taken slightly away from the usual view of things. Here the effect is conversational, a village as you might see it.

Film: Ektachrome 64 ASA
Camera: 6 x 6 centimetres
Lens: Wide-angle
Exposure: 1/4 second at f.22
Filter: Polarising

POINT TO WATCH

● *This photograph has been cropped, taking away most of the foreground which, because the camera had to be kept level, contained far too much uninformative gravel.*

Actors on the Stage

NEAR GERARDMER, VOSGES

The little church and the tree-clump next to it make a single object. Together they share the centre of attention, with the grass field in front of them like an apron-stage stretching into the auditorium. It is a modest domestic scene between actors in the landscape, the buildings performing a perfect little drama of their own. Always look for this if you can, a complementary pair, a visual dialogue, a male-and-femaleness, a balance of opposites quietly conversing between themselves.

Film: Fujichrome 50 ASA
Camera: 6 x 6 centimetres
Lens: Short telephoto
Exposure: 1/2 second at f.32
Filter: 81b warm-up

POINT TO WATCH

● *The sky is too nondescript to have been left quite as naked as this. A graduated filter might have done it some good here, set at an angle so as not to invade the hillside and not too strong so that its presence would remain unnoticed.*

This is a picture made up up almost entirely of *suggestions* – the light on the wood at bottom right, the flickering light in the trees. The only element within it that makes a straightforward remark is the mill itself. But there is a family relationship between the colours and the quality of light in the different parts of the picture. In this family the building – as one solid block of colour, the sort of big splash which nature itself can almost never produce – anchors the composition. It becomes the base-plate around which the whole of the rest of the picture is built.

SOUTH OF RIAÑO, LÉON, SPAIN

Film: Fujichrome 50 ASA
Camera: 6 x 6 centimetres
Lens: Short telephoto
Exposure: 1/2 second at f.32
Filter: 81c warm-up

POINTS TO WATCH

● *A ladder and a higher viewpoint would have taken the trees out of the sky which would have improved coherence.*
● *No polarising filter was used here because to have done so would have taken the reflections out of the river and made the foreground too dark and in too much contrast to the rest of the picture.*

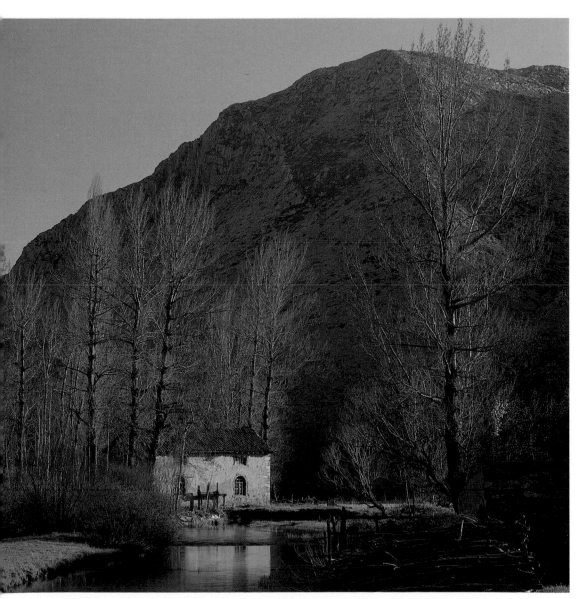

Burying a Building in a Landscape

NEAR CORTONA, TUSCANY

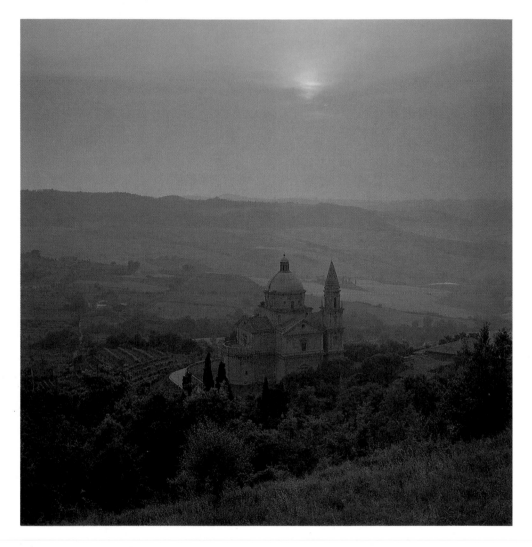

Sometimes there is the feeling that now, at this very moment, a building is showing itself off to its very best. I came across this Renaissance church near Cortona in the evening, at a time when every surface looks softened and absorbent, as if the watery light has leaked into every part of the picture; it seemed to be one such moment. Apart from the quality of the light, I think there is one key to this. And that is the way in which the building is buried in the landscape that surrounds it. It is not, as is usual, stood up against the sky, but included in the hills behind, so that the building is married and melded with the place it inhabits.

Film: Fujichrome 50 ASA
Camera: 6 x 6 centimetres
Lens: Short telephoto
Exposure: 1 second at f.32
Filters: 81c warm-up, low density grey graduated

POINT TO WATCH

● *It is always important to show the whole of a building, or at least enough for you to understand the way in which it works. I had to include the bottom of the apse wall and this meant including, unfortunately, the stretch of road which is the one element in the picture that does not share the dusky softness of texture of the rest of the landscape. This is a compromise and it prevents the picture from being quite perfect.*

I have never seen a place so suited to its name. The little millpond called the Miroir de Scey must have been named precisely because it had been seen in moments like this. Nothing in nature could be so still. So again I was lucky and I arrived at precisely the time I was supposed to arrive. It was an apparition. You can hardly see the join between the water and the hill behind it so that the mill looks as if it is suspended there. The background and foreground have become one. This is taking the principle of burying the building in its landscape almost as far as it can go. Here the mill hangs in its misty half-place as half-visibly, as a spider in its web. Look away and the building might disappear. Look again and it would have returned.

MIROIR DE SCEY, NEAR BESANÇON, DOUBS

Film: Fujichrome 50 ASA
Camera: 6 x 6 centimetres
Lens: Wide-angle
Exposure: 3 seconds at f.22
Filters: None

POINTS TO WATCH

● *The neon light in the building on the right should not be there. I waited for hours for the man to turn it off, but he never did.*
● *Fingers of greenery on the left and right make a mess and intrude on the image. A longer lens which would have cut them out would have cramped the building within the frame too much. Again, a compromise was necessary.*
● *The nature of mist is blue and here that blueness enhances the atmosphere. There would no point in using an ultraviolet or warm-up filter here.*

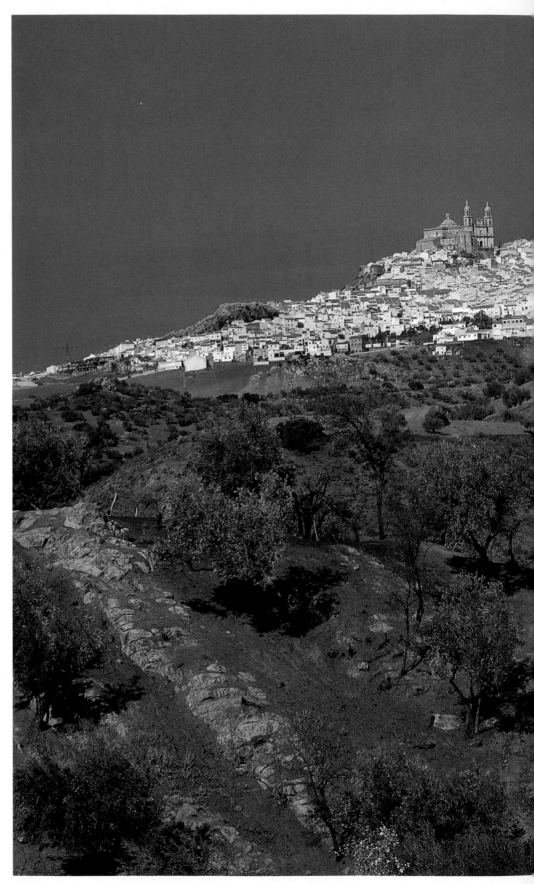

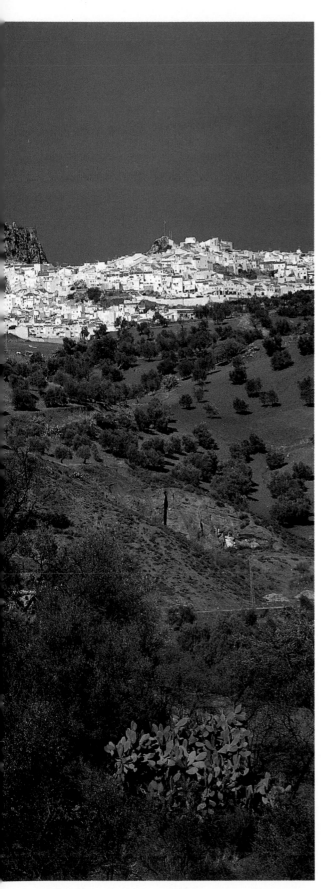

Making Something Strange

OLVERA, ANDALUCIA

The light coming from directly behind me slams straight on to the hilltop town. There is nothing mysterious or atmospheric about this light. It is the hard, bright, full-in-the-face light of midday. But isn't there something extraordinary and strange about this photograph? You might think that slash of white along the horizon is a natural phenomenon, an exposed stratum of white rock in the all-surrounding brown. Only a second glance reveals that it is a collection of individual buildings. So here the relationship of building to landscape has reached at least one form of paradoxical climax. Nothing could be more distinct than the difference between town and not-town, building and not-building in this picture. But at the same time that difference is so severe that the artificial has taken on the appearance of something natural. So do not think that you always have to make a building or collection of buildings in the landscape utterly straightforward. Always look for the strange

Film: Fujichrome 50 ASA
Camera: 6 x 6 centimetres
Lens: Telephoto
Exposure: 1/2 second at f.32/f.45
Filters: Polarising

POINT TO WATCH

● *The foreground, which is not as pretty as I would have liked it to be, could perhaps be cropped a little. But not entirely. The town needs a good spread of foreground to set it in its place and for once quantity matters here more than quality.*

The Big View

The big view is one of the most difficult of all landscapes to get right. It is too easy for a big landscape to look uninteresting unless you help the viewer's eye. The chapter describes some of these aids, leading you towards the distance, establishing a sense of scale and giving the picture a sense of narrative, of something happening.

THE MOUNTAINS of the Peloponnese, which have been seriously overgrazed, used to be covered in forest but now tend to look like bad skin. If one photographs them without any visual help, they can appear unapproachable and, because of that, uninteresting. One has to be led towards them and this visual path between the olives painted with fungicide takes the eye very easily and definitely in their direction.

Any avenue is good, simply for the obvious depth into the picture which it conveys. But for big views, they are almost invaluable.

This may sound like nannying, but avenues, like almost everything else, need very careful handling. You cannot imagine that you can slap down an avenue with some big and distant thing at the end of it, hope for the best and come up with a satisfying picture. Be patient with the composition, look very carefully at the things that go to make it up and then, as I had to here, make the picture work as well as you can.

Here, for example, I knew there was something wrong and the eye was not being led directly enough towards the distance. And then I realised: there were too many little white stones lying around on the soil in the foreground. I moved them, not wanting the distraction they would have involved, but I used a stick, standing to one side, poking and flicking away at them like some arcane fairground game. Nothing would have done more to ruin the picture than a series of large and obvious footprints in the foreground.

NORTH OF VYTINA, ARCADIA, GREECE

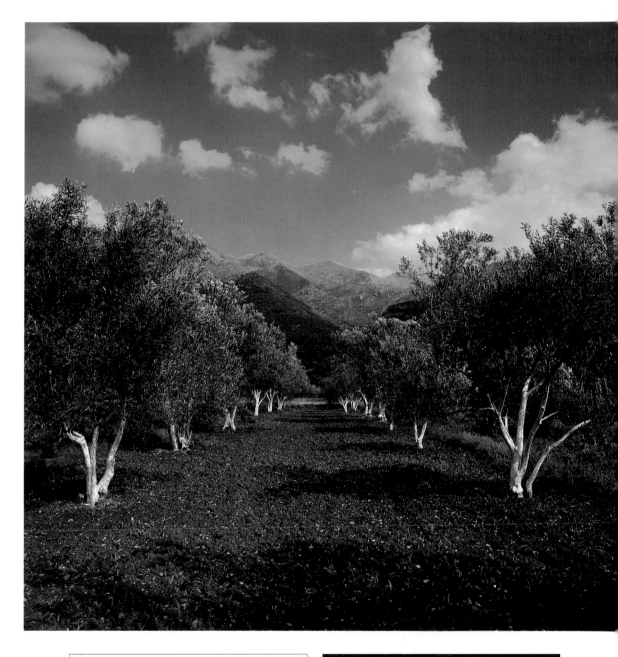

Film: Fujichrome 50 ASA
Camera: 6 x 6 centimetres
Lens: Wide-angle
Exposure: 1/8 second at f.16/f.22
Filters: Polarising, 81c warm-up, low density grey graduated

POINTS TO WATCH

● *I have used the polarising filter to enrich the sky but this has had a cost. The reflected light off the olive tree leaves has been lost, leaving them looking flatter than they would otherwise have done.*

● *The warm-up filter has done well in enriching the red of the soil. This helps the picture structure, simply because the white trunks stand out against it so much more strongly.*

Stepping Towards the Distance

SELASSIA, NORTH OF SPARTA, PELOPONNESE, GREECE

With a big view, it is the relationship between your own standpoint and the distant elements of the view which is all-important. Here you step in three giant strides towards the distant range, each step marked by something quite definite in itself: the trees and flowers; the church; and the grey snow-capped mountains. It isn't perfect. The trees have been damaged, the lower branches are dying, and the church has been over-restored so that it looks too pert, over-smartened when it should look relaxed and natural in the landscape. But the strength of the formal elements holds it all together despite this. This is in fact a picture which succeeds by leaving out the connections between its parts, loping off towards the horizon.

Film: Ektachrome 64 ASA
Camera: 6 x 6 centimetres
Lens: Wide-angle
Exposure: 1/2 second at f.22
Filter: Polarising

POINTS TO WATCH

● *Very important is the bright light on the church against the unlit background. Wait for the sun to play its tricks for you.*

● *The face of the church that is nearest to the camera is in shadow and the rest lit. This greatly enhances the three-dimensionality of an object.*

● *The picture might benefit from some cropping of the sky, to make more of the mountains and to avoid having the horizon coming halfway up the picture. Try it with your hand.*

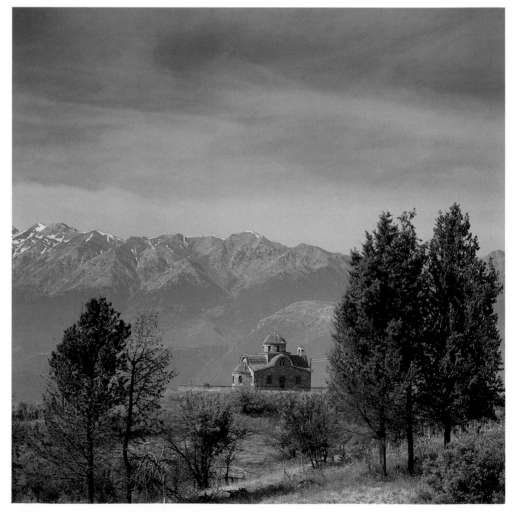

LOCH STACK, SUTHERLAND

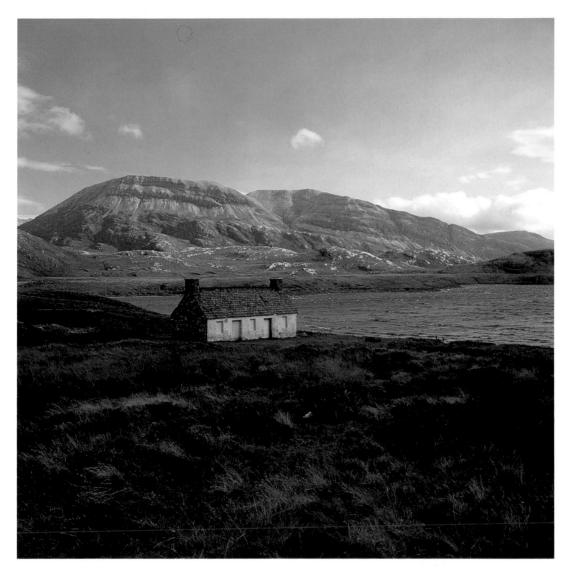

Here the small house is the fulcrum of the picture. It is the place you might want to get to. What lies beyond it is where you will then want to go on. In order to create this intelligible depth in the picture, the house can only be where it is, in the middle distance. Nearer would have made it too separate from the far hills; further away and it would have been too far from us as the viewer. A house plays this role so well because one automatically knows the size of windows and doors. They are scaled to human beings so they make their surroundings knowable by giving them a sense of proportion. A rock in the same place would not have worked.

Film: Ektachrome 64 ASA
Camera: 6 x 6 centimetres
Lens: Wide-angle
Exposure: 1/2 second at f.22
Filter: Polarising, fully polarised

POINTS TO WATCH

● *I should not have used the polarising filter. A glittery surface to the water would have been preferable and density of colour was not a priority here.*

● *The white face of the building makes the point better than if it had been painted a colour that was more in tune with the landscape. This is a case where the building has to stand out from the landscape in order to organise it.*

Giving a Looser Shape to the Landscape

POINTE DE SURGATTE, PYRENEES-ATLANTIQUES

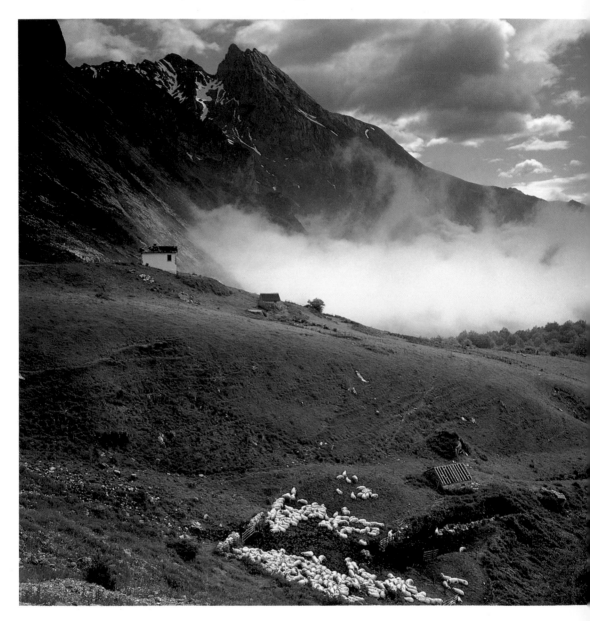

The way in which the flock of sheep at the bottom mirrors the cloud at the back gives a shape to a mountain landscape that might otherwise have been difficult to orchestrate. The little building plays its familiar, fixing role, as the giver of scale and the still point in an otherwise very mobile scene. As it now stands, the organisation is just teetering on the edge of coherence, the elements in it as casual as a scarf draped across a shoulder.

Film: Ektachrome 64 ASA
Camera: 6 x 6 centimetres
Lens: Short telephoto
Exposure: 1/4 second at f.32
Filters: Polarising, low-density grey-graduated

POINT TO WATCH

● *The pink tinge to the cloud is produced by the graduated filter. The picture might have been better without it. Always try and avoid an effect which distracts from the main point.*

134

Rather than stepping back into the view, or having something like an avenue in the foreground that delivers the distant view for you, this road in the Welsh borders provides a sweet, curling line into the distance – a wiggle here, a bend there, passing the house, almost pausing at it, and then on over the brow to a destination one can only guess at. The distance is black with shadow, a sombre presence which alone prevents the picture from toppling over into sweetness. That massive background contains and, like the black sky in the picture of The Manger at Uffington (page. 108), disciplines the charming fore- and middle ground. In a way, the lane could be seen as a relaxed form of the avenue leading one towards the distance, an avenue that has loosened its belt and is wandering carelessly off into the distance.

Again, quite intuitively I have made the lane snake around the centre line of the picture, where it works as the picture's elastic spine.

> Film: Ektachrome 64 ASA
> Camera: 6 x 6 centimetres
> Lens: Wide-angle
> Exposure: 1/2 second at f.22
> Filter: Polarising

POINTS TO WATCH

● *The short telephoto lens compacts the scene, bringing the background into a closer relationship with the farmhouse.*
● *There is a subtle symmetry in the picture, with the lane snaking around its centre line and the blocks of field, wood and hill in understated balance.*

EGLWYSEG MOUNTAIN, CLWYD

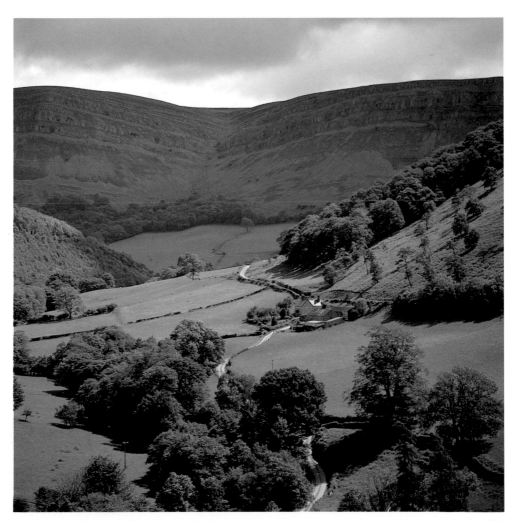

A Sense of Scale

ST BRIDE'S BAY, PEMBROKESHIRE

It is impossible to get any sense of scale in this picture unless you realise that the tiny blip of a figure on the edge of the water is a human being, fishing in the surf that is rolling in off the bay. That figure alone, a thing so out of scale with everything that surrounds him, reveals the bigness of the place and the size of the marine processes that are shaping it. Those rocks in the foreground are shorn off not in tiny, picked-at detail but at the scale of a city block. One lesson emerges: scale can be understood only in relative terms. Something big will only look big when set against something small.

Film: Ektachrome 64 ASA
Camera: 6 x 6 centimetres
Lens: Wide-angle
Exposure: 1/30 second at f.5.6
Filter: Medium density grey graduated

POINTS TO WATCH

● *The lighting conditions as ever are critical. Block out the far highlight on the sea to understand how important that is for the theatricality of the picture.*
● *I did not realise the importance of the figure when I was taking the picture. Allow the chance element to influence you whenever you can.*

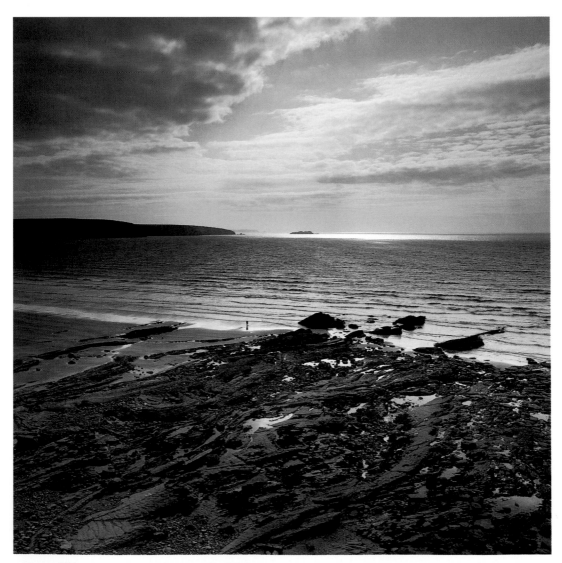

CLAGGAIN BAY, ISLAY, INNER HEBRIDES

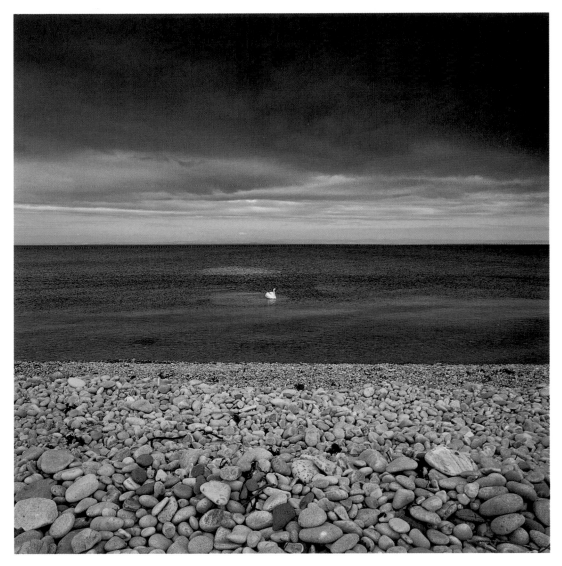

I often wonder if this picture would have worked without the swan. Put your hand over it and the picture remains beautiful, doesn't it? The colour of the sea is so good, the pebbles of the beach are so cleanly and individually identified, the boarded ceiling of the sky is so fierce and dramatic and the pure bandedness of the composition is a pleasure in itself. So the single swan is not essential to the picture. But it does do something: it pins the place to the spot and for that, at least, any photographer is going to be grateful. And it provides the element of the unexpected: the grace of a swan in such a visually harsh and northern scene plays the part of a mole on the cheek of a beauty.

Film: Fujichrome 50 ASA
Camera: 6 x 6 centimetres
Lens: Wide-angle
Exposure: 1/4 second at f.22
Filter: High density grey graduated

POINTS TO WATCH

● *It is important in this picture to have the immediate foreground as sharp as a knife. Press the shutter at the stillest possible moment. And for that it's worth waiting.*
● *Be very careful indeed when using a heavy graduated filter like this. If it begins to look like a filter rather than a natural sky, then the effect it is producing is too strong. To my eye, this looks as if it is just on the edge of being too much.*

The Intimacies of the Landscape

The detail always represents a new way of looking. Whether isolating a graphic pattern, highlighting the corner of a village that seems to sum it all up or suddenly noticing an aspect of nature which the eye normally slides over, the detail is often the approach that reveals the essential qualities of a place.

A SINGLE ROCK masquerades as a lump of abandoned bullion. I had seen it as I was walking along the shore and when still a long way away. It looked almost like a traffic light in its monotone surroundings. But, coming closer, the eye goes on to meet far more in a place than it can first recognise. This became as strange and mystery-laden a landscape as you could find. With its broken and eaten leaves, mixed with flakes of seaweed, the abandoned detritus of an estuary shore, the water boatman resting on the stone, the solid rock surrounded by decay – it is, for me, almost like looking inside a magician's box. Less, like this, can be more: no giant views, no famous landmarks, but the whole workings of a landscape clustered around a golden stone.

It is always important when photographing a detail to make sure that you hold the picture at the right level. To have isolated this stone from its immediate surroundings would have stripped it of much of its meaning. The rock illuminates its own miniature landscape. Without it, the old scurf of dropped leaves would have meant very little indeed, no more than the rubbish in the bottom of the puddle. But it is equally true that the rock itself, shorn of its surroundings, would have lost too, and would have taken on the air of strangeness which, for example, the trunk of the plane tree on page 145 has. Even at this scale, the relationship between the wider landscape and the most prominent object in it is all-important.

ISLE OF SKYE, INNER HEBRIDES

Film: Ektachrome 64 ASA
Camera: 6 x 6 centimetres
Lens: Wide-angle
Exposure: 1 second at f.22
Filter: Polarising, fully polarised

POINTS TO WATCH

● *Make sure there is nothing like a milk bottle top or any other distracting rubbish in a picture like this.*

● *If you think the photograph would look better with the rock wettened and glisteny, then have no hesitation in splashing water all over it. The leaves around the stone might also have been rearranged with some improvement. Perhaps there might have been a few more pale green leaves in there to add extra highlights.*

Close Attention

ARQUES, NEAR LIMOUX, PROVENCE **LE CASTELLET, PROVENCE**

Film: Fujichrome 50 ASA	Film: Ektachrome 64 ASA
Camera: 6 x 6 centimetres	Camera: 6 x 6 centimetres
Lens: Short telephoto	Lens: Wide-angle
Exposure: 1/4 second at f.22/f.32	Exposure: 1 second at f.22
Filters: None	Filters: Polarising, 81b warm-up

Quite often, when you are out taking photographs, you find that the impact of a particular part of the scene in front of you will be more than the whole. The building of which the above picture is a part was, as a whole, muddled by telegraph wires and all sorts of other distractions. But the detail is clean, allowing you to look hard at the colours and textures of the thing in front of you. It also allows something that is simply interesting in itself – a pot or some roses or even a pair of hinges – to take on a role far beyond the part it plays in real life. Photographs of details can in this way be a sort of fantasy zone, miniature landscapes in which very small things take on the importance and place which might be taken by a building or even a mountain in the width of the landscape as a whole. But there is something else in a detailed study: a sense of the preciousness of things, of giving something, for once, the sort of attention which is usually given only in the process of making or preserving or training it. In this way taking photographs of details can feel almost literally creative and you will find yourself absorbed for hours arranging and rearranging the miniature landscapes which detailed photography involves

POINT TO WATCH

● *Details always work well if the light is coming from the side. The slightest bumps or hollows will then create shaping shadows.*

POINT TO WATCH

● *I used a polariser here to knock off the reflections in the shadow. Details require extra close attention – no imbalance, no contamination. I cleaned the cigarette ends out of here. There are unfortunately some tiny bits of paper left. I also experimented with the shutters. When I had both of them open, it took attention away from the urn. With both closed it looked uninviting and cold. This position seemed the most balanced.*

A little house in the Loire valley, slightly the worse for wear and with the paint on the shutters needing another coat (but what a French colour that peeling, fading blue-grey is!): a classic example of the way in which a tightly controlled and isolated detail can describe the whole world of which it is a part. Here is the French village. It takes no imagination to see the people who live in this house, their clothes, the way they stand and greet each other, their bikes, their food, their pets, their clothes...

NEAR ORLÉANS, LOIRE VALLEY

POINT TO WATCH

● *The polariser brings out the reds and blackens the windows. Extreme colour contrast in a small compass always works well. Grey shutters, tan walls, the red swag of roses and the black of the windows: this is the kind of combination to look for.*

Film: Ektachrome 64 ASA
Camera: 6 x 6 centimetres
Lens: Short telephoto
Exposure: 1/2 second at f.32
Filter: Polarising

A Pleasing Pattern

NEAR TARBERT, ISLE OF HARRIS, OUTER HEBRIDES

A peat bog in the Outer Hebrides can be the very ugliest of landscapes, without shape or form, the colours dull, the look little more than a pudding that has been left out in the rain. I was about to leave when from a chink in the corner of my eye I saw this. I saw the repeated angle of the water plants – like a *corps de ballet* – the velvety water, the vibrant yellow set against the black. All those might have been there in a wider picture, but diluted. And this is the point: the detail concentrates the flavours. To make it small means to make it strong, a dense essence of landscape, as distilled as whisky, a sip of landscape concentrate.

Film: Fujichrome 50 ASA
Camera: 6 x 6 centimetres
Lens: Standard
Exposure: 1/4 second at f.22
Filter: Polarising, fully polarised

POINT TO WATCH

● *There is really only one point to watch: make it whole, exclude the excludable and think only of the pattern, not of the place. You must not try and be fair to the landscape. That is not the point. Ruthless excision of the boring can be the only principle. Think of the picture frame as a stage on which you are arranging the players. What happens outside is irrelevant.*

The trees in this bit of Spanish landscape had been burnt. The only impact of this picture comes from the completeness with which the pattern covers the picture surface. If you are relying on recurring elements in a detail then those elements must recur across the whole length and breadth of the image. Imagine for a moment the burnt trees and the flowers petering out at the the bottom left hand corner. The whole picture falls apart and becomes nothing more than a patch of rough ground, not, as it is here, a perfect square cut from a natural tapestry.

GUADALUPE, CACERES, SPAIN

Film: Agfachrome 1000 ASA
Camera: 6 x 6 centimetres
Lens: Short telephoto
Exposure: 1/4 second at f.32
Filters: None

POINT TO WATCH

● *This picture was taken on a fast film and as a result is rather grainy. But to treat something so finely worked in this rough way is often a good idea, a visual contraction in terms which adds a sense of energy that would have been absent in a more finely polished picture.*

Strange Realities

BACINO ORSEOLE, VENICE

Film: Fujichrome 50 ASA
Camera: 6 x 6 centimetres
Lens: Standard
Exposure: 1/8 second at f.22
Filters: None

POINT TO WATCH

● *Keep something at least of the gondola prow recognisable in the photograph. With broken reflections in water choose a moment of relative calm. This frame is only one of many I made, never quite sure at the time which one was going to work. This is an occasion where I would recommend exposing quite a large number of frames.*

Remove something from its surroundings and in some ways you are removing it from reality. These images are at first difficult to piece into the real world. Neither of them has been filtered or distorted in any way. The bark of a plain tree in Le Tholonet or the reflection of a pair of gondola prows in a Venetian canal do appear like this to the human eye but are never seen. The whole secret of finding this sort of photograph lies in actually looking at something over which the eye might normally slide. And to achieve this the only possible advice is: be vigilant and make your eye a lens.

LE THOLONET, BOUCHES-DU-RHONE

Film: Ektachrome 64 ASA
Camera: 6 x 6 centimetres
Lens: Wide-angle
Exposure: 1 second at f.22
Filters: None

POINT TO WATCH

● *It is important even in this miniature scene to get as great a depth of field as possible. Use a very small aperture and long exposure. With something strange, you must allow the viewer to see as much of it as you can. The fact that the right-hand edge of the tree trunk is visible helps a great deal in identifying the subject.*

The Final Shape

After you have exposed your frames and had them returned from the processors you must decide what shape prints you would like to make of them. Ideally, the picture was already perfectly composed in the viewfinder of the camera, but that cannot always be the case. The chapter shows you how to improve your pictures by cropping them.

I WALKED OUT IN armpit-high fisherman's waders to reach this point midstream of a cold and fast-running river, thick with melt-water from the snows in the Pyrenees. I knew when I arrived in the valley, with this wonderful sky, bannered with cloud, that there was a good picture here.

I exposed some frames from the bank but they did not work and so I found myself strapping on the waders. The picture I found in midstream works on the basis of a system of interlocking symmetries. The first is hinged to the apex of the rock in midstream, creating a star-shape over the whole frame. The two banks of the river come away and down from that point; the horizon of the ridge on the left and the tops of the trees on the right move away and up

from that point. The texture of the two areas they enclose – the flecked sky and the broken water of the river – are reflections of each other.

Within this radial system of symmetries, there is another three-banded element consisting of the low boulders in the foreground, the central boulder and the distant mountain, three steps back into a landscape of perfectly arranged parts.

You couldn't cut anything out of this picture without diminishing it. All the cropping was done on the spot with the frame of the camera itself. And I knew it at the time, a whooping sense of delight. This was indeed the final shape there in front of me, when for a moment the landscape itself was displaying all the brilliance of a flag.

RIVER ESERA, SOUTH OF CAMPO, HUESCA

Film: Fujichrome 50 ASA
Camera: 6 x 6 centimetres
Lens: Wide-angle
Exposure: 1/8th second at f.16
Filters: Polarising, 81a warm-up

POINTS TO WATCH

● *This is a case where the polarising filter comes into its own, accentuating the drama of the sky.*
● *If I had panned too far to the left there would have been too much unlit hill. Reduce very dark areas as much as you can.*

● *In the light of the setting sun, the last twenty minutes seem to go by in a flash. A few minutes later there would have been no light in the left of the picture, the bushes on the island on the left would have been unlit and there would have been no picture here to have been taken.*
● *A higher vantage point is always better than a lower one and if I had dared I would certainly have tried to have taken my stepladder out into the middle of the stream. But I did not think the collapse and drowning of photographer and camera was quite worth it.*

Cutting out the Competition

AIOZ, NAVARRA

As this picture stands, there is too much of the track in the foreground.
It competes with that astonishing cloud for its place in the picture. It is quite clear that the giant ball of a cloud is the more interesting of the two. Put your hand over the cloud look at the picture again. It works perfectly well, becoming a photograph of what you expect of the Spanish plains: a gritty road disappearing into nowhere, long long horizons, a place of almost shadeless heat. But then take your hand away and the picture returns to its state of imbalance, of indecisiveness.

One has to go and it is obviously the track or most of it. It has been cropped to this effect on the opposite page. It becomes a photograph of something else entirely. The minute scale of things on the landscape are revealed if one cloud can so dominate such a wide sliver of terrain. The cloud is an object of huge and fuzzy drama. The photograph has started to assume the air of a picture of earth's atmosphere taken from space.

But things have changed in the landscape as well. The clump of trees on the knoll in the distance has become important for the way the picture works: without them there is no focal point, with them the scale of the cloud is revealed, or to be more precise the difference in the scale of things in the landscape and in the atmosphere is revealed. It has become a picture of how the global meets the local.

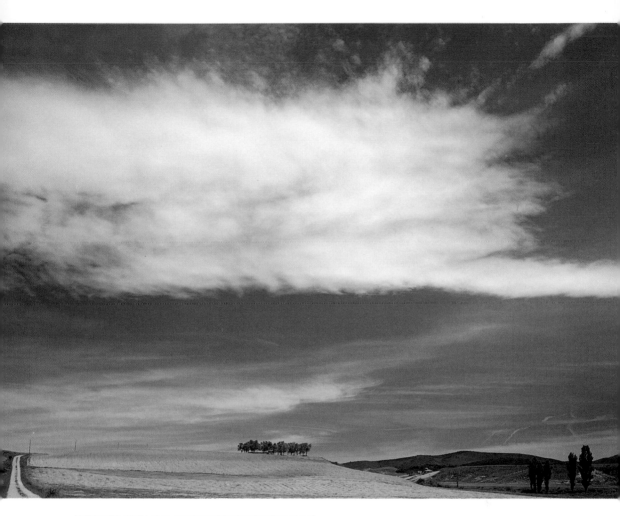

Film: Fujichrome 50 ASA
Camera: 6 x 6 centimetres
Lens: Wide-angle
Exposure: 1/4 second at f.22
Filters: 81c warm-up

POINTS TO WATCH

● *The way in which the left-hand edge of the track is clipped off by the frame is annoying and careless. It would also have been better if the right hand edge of the track came down to meet the bottom right hand corner of the frame. One of these faults was avoidable – it is sheer carelessness – the other is something which might have been wished for in a perfect world. Nevertheless, it may well be precisely these failures of minute detail which make the bottom half of the original picture slightly unsatisfying. Imagine the full square frame with the stub end of the track broadening out to occupy the whole of the foot of the picture. Would the urge to crop it still have been there in that case?*

● *I wonder, looking at it now, whether the crop has been made a little too high. Would the cropped picture have been more satsfying if the little sliver of yellow had extended right to the edge of the frame under the five poplar trees? I think it might well have been, somehow completing the movement of the landscape itself from left to right across the picture. As it stands, the field looks a little truncated, and that is an impression which one should try never to give. Attempt always to make the meaning of a picture whole.*

● *It would have been much nicer if the cloud had been complete and not cut into on the left hand side. But this was a compromise. I needed the balance in the landscape between the track on the left and the little group of poplars on the right. If I had moved the track any nearer the centre of the frame, that balance would have been disturbed, the crucial group of trees in the centre on the horizon would have been moved out of position and the whole composition of the picture would have fallen apart.*

Cleaning Up

EAST OF RONDA, MALAGA, SPAIN

The lines of olives in the background are a pattern which I would have liked to make much clearer in the photograph. As it is, I did not really succeed. The trees fall out of the picture to left and right and the structure of the landscape is muddled.

The rock in the foreground is of huge importance in the way the picture works, but it is not in the right place. The scurfy patch at bottom right is a classic instance of what not to include in a photograph, a jumbly, uninformative area of dead ground, into which the meaning of the picture leaks away. It is, in itself, a sign of loss of control.

So here it is a question of salvaging what I can from the picture to make it something that pleases. What can one do? First of all we have to lose the sky because it is weak, a wretched little sky, which shows all the signs of impatience, neither balanced, nor shapely in itself, nor reflecting the forms of the landscape beneath it. The bottom right of the picture has to follow it and the great crusted rock in the foreground has to be brought on to centre stage. This is a simple process of cleaning up in which you can be as ruthless as you like.

The cropped result, opposite, at least has a certain look of integrity to it. The boulder becomes twinned to the mass of raw limestone mountain in the background. The olives, although still not as coherent as I would like them (there is for example the

area at the back on the left which is a little tentative and undecided) are now more plainly ranked than before. The asymmetries of the sky have been removed and it now forms a fairly harmless band at the top of the picture, undistracting, the fourth stripe against which the banding of the landscape itself is set. Tidier, not perfect, but a perfectly workable picture.

POINTS TO WATCH

● *I should perhaps have waited for a better sky. If some beautiful clouds had appeared I wouldn't have taken the sky out of the picture. But where* there is no sky to speak of you can always take it out. No sky will always be better than a poor sky.
● *Cropping like this can salvage something, but you can be sure that it can rarely do as well as patience and skill when you are out in the landscape itself. Try not to trust to cropping to make your pictures work for you. Look hard and be patient when the camera is in your hand.*

Film: Fujichrome 50 ASA
Camera: 6 x 6 centimetres
Lens: Standard
Exposure: 1/4 seconds at f.22
Filter: Polarising

The Photograph Designed for Cropping

SOUTH OF ANDUJAR, JAEN, SPAIN

Incredibly strong blocks of colour and almost rigid geometries like these are the moments when the natural world starts to take on its most unnatural aspect. Here is a landscape which a child might draw but which, you might think, could never occur in the subtle setting of the real world. But it does and when you are faced with a picture like this, the natural inclination is to treat the landscape in the way that, in a sense, it is treating itself. Exaggerate it, take the signs it is making and push them as far as you can go. Of course with colours and sunshine like this you must use a polarising filter, saturating the film with colour so rich that it is almost stark.

And then when you have the colour oozing out of the film you must decide on what shape the photograph must have to bring out this intense unnaturalness. Cropping can be – and often is – a very disrespectful process. It is not about showing the full reality of what is there. The very opposite of that. It is taking the landscape and shearing away anything that might get in the way of a particular meaning you want to convey.

When I was taking this picture, I knew I would have no need of the sky when it came to printing it. The sky would set the olives and poppies too sweetly in their real setting. I didn't want such clear information. I wanted to mystify and amaze with the picture. This is something I almost never do.

I am usually keen on explanation, clarity and fullness of meaning. But here I was doing no more than respond to the landscape on its own terms: treating coarsely something that was almost almost unbelievably coarse itself. The cropping had to take out all the sky, all hint of a horizon and and those patches in the field of poppies where the density of colour was not quite all it might have been.

You will hear many photographers say that cropping is a vulgar and lazy practice. Everyone should compose their pictures in the viewfinder or on the ground-glass screen of the camera. It is, like all counsels of perfection, a very seductive and tempting idea. No doctoring after the fact, no fiddling for effect where you had failed in front of the landscape itself, no 'cheating.' And part of me is very sympathetic to that. I love the idea of photography as a pure art, a straightforward response to landscape of man with a camera in his hand. But I know too that it is not always like that. I know there are days when things do not go sweetly, that the world is not falling in to your lap. Of course it doesn't! And of course not all photographs will work as they were framed up. One can look at cropping as an improving art, one that can be practised with delicacy and skill. It will always be useful in the making of a point, in highlighting a particular aspect of a photograph which would have been lost without any cropping. I must say that the pictures I have taken which continue to please me were all composed in the camera itself. But perhaps there is no need to be quite so pious about it. They are, after all, only photographs.

Film: Fujichrome 50 ASA
Camera: 6 x 6 centimetres
Lens: Telephoto
Exposure: 1 second at f.45
Filters: Polarising

POINT TO WATCH

● *Looking at the cropped picture now, I wonder if the sky should have been removed. Would a three banded flag of a picture have done the job better than this two banded slice? I am not sure. And again it is worth considereing whether the division between the poppies and olives is quite right. Should the line between them be slightly lower down the picture?*

Glossary

Aperture The hole in the **diaphragm** through which light enters the camera to fall on the film. Varying apertures control **exposure**.

ASA The abbreviation for **A**merican **S**tandards **A**ssociation used to measure **film speed**. Films that are very sensitive to light, or fast films, have a high ASA number and those which need a longer exposure have a low ASA number.

Backlighting A situation where the main source of light is behind the subject of the photograph and so the light falls directly on the lens. Often a beautiful form of lighting, giving a halo to the subject, but in these circumstances you must watch for **flare**.

Bracketing Used particularly with transparency film as a way of not losing opportunities, a system of making exposures above and below what you guess to be the right one but are not quite sure.

Colour conversion filter A filter used to re-adjust a film to lighting conditions for which it was not manufactured, for example an 80a, which is blue, must be used when daylight-balanced film is used under tungsten light and an 85b when tungsten-balanced film is used in daylight.

Colour correction filter Another term for **warm-up filter**.

Contrast The difference between the darkest and lightest parts of a photograph. Make it a point of principle never to have the lightest parts so light nor the darkest so dark that no detail is visible in them.

Definition The precision with which the photograph has reproduced the subject. High **film speed**, shallow **depth of field**, failure to focus the camera or to make the tripod rigidly still all reduce definition.

Density The darkness or paleness of a photograph. As a rule, slow **film speeds** will increase colour saturation and so the density of a photograph.

Depth of Field A measure of the distance between the furthest and the nearest object in the photograph which are both in focus. Small **apertures** increase depth of field, large ones reduce it.

Diaphragm The mechanism in the lens consisting of a circle of metal blades that control the size of the **aperture.**

Emulsion The light-sensitive coating on a film on which the photographic image is recorded.

Exposure The amount of light falling on the film which is controlled by a combination of the **aperture** and the length of time the shutter is open.

f-number The measure of the aperture. A large f-number means a small aperture, a small f-number means a large aperture.

Film speed The sensitivity of a film to light. High-speed films are useful for freezing rapid motion in a subject, for using in low-light conditions and for making a photograph with a large **grain**. Low-speed films achieve a far greater colour-saturation and achieve richer colour-effects in a landscape.

Filter A glass or plastic sheet placed over the front of the lens to alter the quality of the light entering it. Several different sorts of filter can be used at one time.

Flare When strong light, from the sun or a lamp, shines directly into the camera, it can bounce off elements within the lens and create bright, geometrically shaped, over-exposed areas on the image. This is flare and can often be avoided by using a **lens-hood**.

Grain The large particles that appear on an image either when it is greatly enlarged or when a very fast film has been used.

Graduated filter A series of filters, coming in a variety of different densities, from low to high, and colours, including grey, tobacco, blue and so on. The filters darken only one part of the photograph. They are consistently useful in bringing the sky within the same exposure range as the landscape below it, although they must be used carefully when the horizon is interrupted by trees, hills, buildings and so on: nothing looks worse than half a hill bright and half artificially darkened.

Lens hood A cloth hood that fits on to the front of the lens to shade it from direct light and so avoid **flare**. With a wide-angle lens be careful not to catch part of the hood in the corner of the photograph. A hand can sometimes do just as well.

Neutral density filter A colourless grey filter that cuts down the amount of light reaching the film over the whole surface of the photograph. Particularly useful with long exposures where you want to record the movement of the subject in front of the lens without overexposing the film.

Polarising filter A filter that cuts out the polarised light which is usually created by reflections off a surface. It has the effect of enriching colour in both the sky and the landscape.

Shutter speed The length of time the film remains exposed.

Standard lens The lens that represents without distortion or compression a view of a landscape similar to the unaided eye.

Stop The unit by which an exposure is measured. A change of one stop, either in **shutter speed** or in **aperture**, represents a doubling or halving of the amount of light reaching the film.

Telephoto lens A lens that apparently brings the subject closer to the camera. It compresses elements within a landscape and has a shallow **depth of field**.

Tungsten balance film Film that has been adjusted to read the correct colours of a subject when lit by the artificial light created by an incandescent tungsten filament.

Ultra-violet radiation Part of the spectrum of light emitted by the sun which is invisible to the human eye but can be picked up by colour film as a bluish cast. An ultra-violet filter should be used to cut this out, particularly in hot, dry climates.

Warm-up filter Another name for the 81 series of **colour-correction filters**, used to add warmth and knock the blue coldness out of photographs, particularly in the shade.

Wide-angle lens A lens that encompasses a wider slice of the landscape than a standard lens.

Technical Notes

Camera

Every photograph in this book was taken with a Hasselblad 6 x 6 centimetres roll-film camera. I should explain why this is the perfect choice for me. First, the size of the transparency, which is about four times the area of a 35 mm transparency, means that the quality and texture of the final print will never suffer from enlargement. Secondly, the roll film is loaded into a removable chamber at the back of the camera and so it is possible to change films (black and white to colour transparency, fast to slow, slide film to polaroid for a near-instant check on exposure levels) without wasting frames on each film. And thirdly, the camera is heavy, bulky and unautomated. That might seem to be a disadvantage but I have found this to be exactly the right equipment for the sort of photographs I like to take. With a camera like this you always have to spend some time with the landscape, preparing yourself and the camera, and that time is never wasted.

Tripod

Almost nothing is more important than the reliability and strength of your tripod. Photographs that need good definition right up to the immediate foreground need long exposures and complete stability for the camera. Get as heavy a tripod as you think you can carry. It is also well worthwhile buying a tripod that includes a spirit-level, which is a far more trustworthy guide to a level horizon than your own eye.

Light meter

Many modern cameras include a through-the-lens light meter which, together with the automatic exposure controls, adjusts the settings for you. This is all right for a beginner but I would always recommend moving beyond that to a hand-held spot-meter with which, like one lens of a pair of binoculars, you can measure the intensity of light in any part of the photograph. That inevitably brings you closer involvement with the light conditions that surround you.

Film

Most of the photographs in this book have been taken on rather slow colour transparency film, either Ektachrome 64 ASA or Fujichrome 50 ASA. There is no doubt that this sort of film needs quite precise control and for any one photograph reproduced here I probably made four or five different exposures, precisely because with this sort of film very little adjustment can be made later at the processing stage. Colour negative film and black and white film are both far more generous to the photographer who has made incorrect exposures, which can be adjusted for in the processing and printing stages. So why choose colour transparency film? Because only it can convey in sharp detail the true colour, richness and beauty of the landscape. And that, of course, in the end, is what I am there for.

Index

abstract effects 31, 48
 see also: graphic images; patterns
animals 23, 41, 80, 86, 137
aperture, small 35, 62-3, 48, 114, 115
arrangement of parts 16-29
 and colour 94-5
 detail 139, 140, 142
 layers 59
 loosely controlled 22-3, 134-5
 simplicity 30-1
 see also: balance; contrasts; distractions;
 focus of interest; highlights;
 symmetry
attitude to landscape 6-15
avenues 130

background 43, 45, 55, 135
backlighting 31, 48, 82, 90, 100, 115
balance
 arrangement of parts 20-1, 30-1, 43, 56, 95,
 106, 123
 colour 118
 cropping to achieve 148-9
 light and 92-3, 95
beach, wet 52-3, 118-19
big view 130-7
blueness 39, 43, 64-5, 72, 127
buildings 120-9
 in big view 132-3
 detail 140, 141
 in evening light 44, 45, 46
 graphic image 50-1
 placing in frame 122-3, 126
 reflected 46, 122, 127
 sense of scale 16, 133, 134
 shadows 16-17, 44, 71, 122, 132
 verticals 50, 51, 122

close-ups 31, 51
colour 94-103
 buildings 125, 133
 complementary/uncomplementary 96-7
 contrasts 18, 141
 correction filters 67, 75
 dramatic 94-5, 99, 152
 evening 44, 77
 film speed and 68
 light and 90-1, 97
 and long exposures 63, 67
 near-monochrome 48, 100-1
 reducing very dark areas 147
 simplicity 18, 25, 98, 99, 94-5
 see also under: highlights; polarising filter;
 warm-up filters
completeness 34-5, 90, 88-9, 146-7
contrasts
 in arrangement 21, 35, 86, 114, 124
 colour 18, 141
 light and dark 31, 86
cropping 146-53
 of competing focus 148-9
 of distractions 41, 44, 113, 123, 152
 limitations 151
 picture designed for 152-3
 to match subject 36-7, 51
 of sky 44, 132, 151

definition, loss of 44, 45, 80
depth of field
 aperture and exposure 35, 48, 62-3, 114, 115
 and graininess 69
 long lens reduces 55
 and speed of film 63, 115
 and details 144
 wide-angle lens 48

detail 138-45
distractions 18, 19
 created by misuse of filters 134
 cropping 41, 44, 113, 123, 152
 at edges 23, 41, 62, 96, 98
 foreground 63, 84, 113, 123, 130
 in graphic images 142
 long lens to eliminate 56-7, 127
 physical removal 63, 130, 139

edges of frame
 clipping objects 19, 43, 56, 62, 80, 90, 149
 distractions 23, 41, 62, 96, 98
evening light
 after sunset 96
 buildings in 46, 126
 colour 44, 77
 dramatic 46-7
 exposure for 39
 investigative 44-5, 114
 polarising filter 47, 101
 shadows 40, 44-5
 speed of loss 46, 147
 sunsets 110-11
 textured effect 34
 warm-up filter and 34, 47, 76-7
exposure
 colour in long 63, 67
 and depth of field 35, 48, 62-3, 114, 115
 in evening light 39
 and film speed 63, 66-7
 with polarising filter 71
 special effects 11, 66-7
 for spotlit landscape 79
 with warm-up filter 72
 for water 25, 60, 66, 115
 with wide-angle lens 48
 see also: movement
exposure meters 72

figures in landscape 67, 136
filters 68-77
 colour-correction 67; (80a) 75
 neutral density 67
 overuse 47, 72, 109, 127, 133, 134
 soft-focus 68-9
 ultra-violet 85, 127
 see also: grey graduated, polarising *and*
 warm-up filters

flare 31, 48, 52, 82, 1-7, 110
flash light 75
focus of interest
 double 56, 124, 148-9
 placing of 19, 33, 39, 123
foliage 76, 86, 88-9
footprints, photographer's 81, 130
foreground
 and background 43, 45, 55, 127, 135
 cropping 44, 113, 123
 distractions 63, 84, 113, 123, 130
 footprints 81, 130
 lit 84-5
 long lens photographs 55
 tidying up 31, 33, 63, 130

ghostly effect 67
graininess 68, 80, 115, 142
graphic images 18-19, 31, 50-1, 142-3, 152
grey graduated filter
 clipping horizon 52, 82, 85, 100
 enlivens sky 22, 90-1, 100, 124
 strength, choice of 27, 137
 at sunset 110
 tones down sky 11, 52-3, 100, 118
 with polarising filter 54, 71

haze 85
high viewpoint 41, 50, 55, 59, 108, 121, 147
highlights
 and balance 95, 116-17
 colour 57, 125, 133
 in big view 136
 white 23, 39, 116-17, 133
horizon
 keeping level 36, 48, 52-3
 objects breaking 35, 41, 121, 125
 placing in frame 36, 110, 132

isolated objects 32, 33, 36-7, 62

ladder, step- 41, 50, 55, 59, 121, 147
layers 59, 146-7, 132
 light and 80-1, 84-5, 86
 long lens compacts 18, 48, 55, 135

lens-hood 31, 48
lenses 48-57
 long (telephoto) 18, 44, 48, 54-5, 56-7, 62, 135
 shading of 31, 48
 short telephoto 55, 86, 135
 wide-angle 36-7, 48-51, 52-3, 54-5
light 10, 40-7, 78-93
 and balance 92-3
 catching passing 12-13
 and colour 90-1, 97
 contrasts 31, 86
 diffuse 88-9
 dramatic 46-7, 92-3
 flash 75
 flat 35, 76, 78, 88-9, 90-1
 and layers 80-1, 84-5, 86
 low 42-3, 78, 101, 106 (see also: evening)
 midday 35, 76, 78
 morning, early 40, 58-9, 76
 splashes of 79, 82-3, 122, 132
 spotlights, natural 78-9, 132
 time of day and 40-7
 tungsten 75
 see also: backlighting; evening; highlights; reflections; shadows; sidelighting
litter, removal of 33, 139

mist 127
monumental object 38-9
morning 40, 48, 58-9, 76
movement 58-67
 and exposure 58-67: blurred 25, 34, 60-1, 62, 64-5, 80, 97, 99, 112; stilled 60, 66, 82, 113, 114, 115, 144
 smoke 88-9

patterns 105, 142-3
permanence of landscape 8-9
polarising filter
 colour enhancement 20, 54, 70-1, 95, 141, 152; loss of reflection 35, 86, 125, 131
 in evening 47, 101
 exposure increased for 71
 grey-graduated filter used with 54, 71
 half-polarised 71
 overuse 47, 109, 133
 and reflections 35, 46, 64-5, 70, 86, 125, 131

 and shadows 20, 76, 140
 and sky 54, 70, 71, 109, 131, 147
 for underwater vision 64-5

receding structures 35, 48, 130
recurring elements 105, 142
reflections and reflected light 27
 and balance 22
 on beach 52-3, 118-19
 broken, in water 144
 buildings 46, 122, 127
 danger of flare 107
 and loud colour 95
 movement in 99, 113
 of sky 86, 114
 polarising filter 35, 46, 70, 64-5, 131
 wetting elements to create 25, 139
rubbish, removal of 33, 139

scale, sense of 133, 134, 136, 137
sea 52-3, 64-5, 100, 116-17, 118-19
shadow 85
 avoid clipping 62
 of buildings 16-17, 44, 71, 122, 132
 cast by backlighting 19
 'false' 35
 of photographer or camera 105
 polarising filter and 20, 39, 43, 76, 140
 give substance 16-17, 40, 44-5, 71, 132
 winter 42-3
sidelighting 17, 71, 132, 140
silhouettes 99
simplicity 30-9
 and colour 18, 25, 94-5, 98, 99
 in graphic images 18
 of light before dawn 40
 monumental object 38-9
 single objects 32-3, 36-7
single objects 32-3, 36-7
 repeated 105
sky 104-11
 blue; half-polarised 71
 cropping 44, 132, 151
 earth, relationship with 35, 104-5, 106-7, 114
 excluding 19, 34, 44, 56, 69, 132, 151
 polarising 54, 70, 71, 109, 131, 147
 reflections of 86, 114
 sunsets 110-11
 toning down 11, 52-3, 54, 71, 100, 118

warm-up filter for 11, 90-1
see also: grey graduated filters
smoke 88-9
snow and frost 39, 43, 72
speed of film
and colour 68
and definition 68, 80, 115, 142
and exposure 63, 66-7
spirit level 36, 52-3, 122
spotlights, natural 78-9, 132
strangeness 20, 67, 127, 144-5, 152-3
sun, photographing 26-7, 110
sunsets 110-11
symmetry 20-1, 105, 135, 146-7

textures revealed by low light 34, 106
tidying up subject 31, 33, 139
tilt of camera, change in 26-7
time of day 40-7
traffic, moving 48
tripod 63
tungsten light 75

vapour trails 121
verticals 50, 51, 122

warm-up filters 72-5
81 series 72-3
85 series 74-5
enhance warm light 97
and evening light 34, 47, 76-7
exposure increased for 72
and foliage 76, 88-9
and morning light 76
over-use 47, 72, 127
sepia effect (81ef) 72
on sky 11, 90-1
on snow or frost 39, 43, 72
for spotlit landscape 79
for tungsten light 75
and white areas 51, 64-5, 72, 131
and yellows 32, 88-9
water 112-19
on beach 52-3, 118-19
moving: blurred 25, 60-1, 64-5, 99, 112;
stilled 60, 66, 115, 144
like molten metal 107, 112
underwater views 64-5, 116-17
see also: reflections
waterfalls 25, 112
white
distracting 63
warm-up filter and 51, 64-5, 72, 76, 131
wind 32, 34, 35, 57, 58, 64, 114
winter 42-3, 101